TANGLE
journey

TANGLE
journey

**EXPLORING THE FAR REACHES OF
TANGLE DRAWING, FROM SIMPLE STROKES
TO COLOR AND MIXED MEDIA**

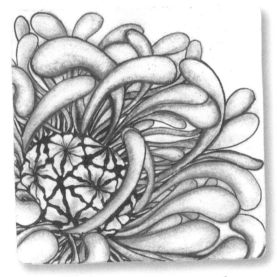

Beckah Krahula

Quarto is the authority on a wide range of topics.

Quarto educates, entertains and enriches the lives of our readers—enthusiasts and lovers of hands-on living.

www.QuartoKnows.com

First published in the United States of America in 2016 by
Quarry Books, an imprint of
Quarto Publishing Group USA Inc.
100 Cummings Center
Suite 406-L
Beverly, Massachusetts 01915-6101
Telephone: (978) 282-9590
Fax: (978) 283-2742
QuartoKnows.com
Visit our blogs at QuartoKnows.com

10 9 8 7 6 5 4 3 2 1

ISBN: 978-1-63159-055-9

Digital edition published in 2016
eISBN: 978-1-62788-347-4

Library of Congress Cataloging-in-Publication Data

Krahula, Beckah, author.
 Tangle journey : exploring the far reaches of tangle drawing,
from simple strokes to color and mixed media / Beckah Krahula.
 pages cm
 ISBN 978-1-63159-055-9 (paperback)
 1. Drawing--Technique. 2. Drawing materials. I. Title.
 NC730.K69 2015
 741.2--dc23 2015034977

Design: Laura Shaw Design, Inc.
Photography: Studio photography by Glenn Scott Photography

Printed in China

For a video of the coptic-stitch binding technique, go to www.quartoknows.com/page/tangle-journey
or to Beckah's website, Beckahnings.com.

The Zentangle © artform was created by Rick Roberts and Maria Thomas. Zentangle materials and teaching tools are copyrighted. "Zentangle" is a registered trademark of Zentangle, Inc.

For those who keep creating and changing our world

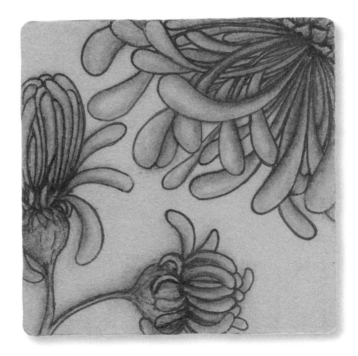

Contents

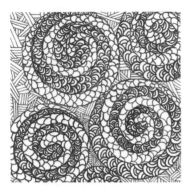

Introduction

As a passionate "tangler," I am not surprised to see how tangling has spread worldwide into an ever-growing art movement with enthusiastic participants. People who previously had never picked up a drawing pen don't leave home without one now, creating images two or three times a day. These new artists began drawing to reduce stress, refocus, and create through Zentangles®, but they now find themselves taking tangles off the tiles and creating Zentangle-Inspired Art, or ZIAs, which are art pieces of any size, color, or medium that include one or more tangles. These tangled designs become incorporated into the artist's repertoire, adorning their worlds by influencing and appearing in their other works. In my teaching travels around the world, I have found tangled walls, floors, cars, clothing, purses, shoes, accessories, paintings, bedding, rocks, murals . . . the list is endless.

Everyone has a personal artistic style, a combination of all that we experience throughout our lifetime. The only person who knows your style is you. As artists, we are on a creative journey, constantly taking in inspiration, growing and changing from our experiences. In this book, we will continue our tangle journey with a strong focus on defining our unique, personal style. Some of the lessons in this book may speak to you immediately, and you will thoroughly enjoy these as you work. Others may challenge you. I encourage you to embrace the challenging exercises. Create to discover, learn, grow, and achieve.

Each chapter begins with creating a sketchbook that is tailored to the lessons within. These sketchbooks become the journals of our journey, the memories and references that you will treasure and use for the rest of your creative life. Take time to explore the options for your supplies and papers at local art stores. You do not need huge sets of colored pencils, pens, or paint. Start with a few basic colors; take the time to try them out at the art store. You can gradually add colors as you create new projects. The supplies are to use and enjoy, so give each a try to ensure you like the medium's feel, texture, and color. Paper choice is also very important. Study each type's recommended uses, finish, weight, and coloring. I encourage you to use 120 lb paper (at least) for drawing, 140 to 240 lb for mixed media, and 240 to 300 lb paper for metal point, mixed media, and collage. Most of the projects in this book are made from one or two parent sheets of 24" x 30" (61 x 76.2 cm) paper. Save your scraps, because we will use them throughout the lessons.

I encourage you to bring the art you are creating into your lifestyle. We will create art pieces in which we use segments from our sketchbooks. Keeping the artwork small will enable us to experience how to begin a new project as well as the crucial process of working through and finishing each piece.

In *One Zentangle a Day* (OZAD), we learned to tangle, working with our intuition and creating meditative tiles to achieve a higher state of focus; we learned the fundamentals of art and design and, most importantly, we learned how to draw. The basic steps are reviewed on the following pages. *Tangle Journey* picks up where OZAD left off, leading you on a new quest to explore your personal style and dive deeper into the world of tangled art. I encourage you to start each lesson by creating a Zentangle to get into the zone and become acquainted with some of the new tangles in the book. There are many aspects we learn from tangling that we transport from tile to sketchbooks to planned art pieces. As journeymen, we must heed our instinct and intuition as we work, combining these with all our acquired art knowledge, to go boldly forward on our tangle journey.

Getting Started Primer

Zentangle can really be done anywhere, as long as you can hold your tile, pencil, and pen. Always keep a mini kit close at hand in case you want to refocus, feel inspired, need to alter your mood or stress level, or want to alleviate boredom.

To get the most out of your Zentangle journey, create a time and space where you can spend thirty minutes creating your daily Zentangle. This does not require setting up a studio. Find a space you enjoy being in. Make sure you have good lighting, a table or hard surface to work on, and a place to sit. The area should be free of interruption. Background music can be great for drowning out irregular interruptive noise. Choose something that will allow you to relax but stay focused and not put you to sleep.

The art evolves from a border, string, and tangles that are drawn on the tile. A tile is a 3½" x 3½" (9 x 9 cm) piece of drawing paper.

To get all the benefits from Zentangle, it is important to follow the process. Simple steps naturally progress from one to the other with no need for planning. First, a pencil is used to draw a dot in each corner, and the dots are connected by a line to create a border. Next, the "string" is created with the pencil. A string is an abstract shape that divides the area inside the border. These divisions are filled with tangles that are drawn with an 01 drawing pen. Tangle patterns are made from a series of repetitive, easy-to-create, deliberate pen strokes. The process is very rhythmic, centering, and relaxing. By following the same steps each time, a ritual is created. The ritual becomes more familiar, comforting, and calming with use. Benefits such as developing new skills while enhancing old ones, stimulating creativity, purposefully redirecting your mind and thoughts, improving focus, calming and centering the mind, and releasing stress become easier to achieve. The eleven steps are as follows.

1. Relax, stretch a little, and make yourself comfortable.

2. Breathe—a few nice big breaths in and out. Smile. Remember to enjoy being in the moment.

3. Examine and admire your tools and your paper, and appreciate this time to create.

4. With your 2H pencil, create a light dot about ¼" (6 mm) in from each of the corners of the tile. No need to measure; just place them where it feels right.

5. Using the 2H pencil, draw a line from dot to dot, creating a border. Don't worry about it being straight, because the eye finds curved lines more interesting.

6. Create a string. The string creates a division of areas in which to lay tangles. It is the creative map of your daily Zentangle journey. The string can be any shape or size, and on any spot inside the square; it doesn't have to be a continuous line. The string is meant to dissolve away into the background of the finished Zentangle like an invisible border or edge. Never draw the string in ink, because then it creates a border that becomes the focus, much like the effect found in a coloring book, and then it is no longer a suggestion; the string becomes a rigid border that limits the options for placing tangles. When the string is in pencil, experienced tanglers can study the piece and imagine what the string looked like when drawn.

7. Pick up an 01 drawing pen. Turn your tile and examine the pattern that the string makes from each angle. Hold it out at arm's length so you also see the composition from a distance. Following your first impulse, start filling in each section of the string with a tangle that you feel fits. Do not overthink your decisions, and do not hurry. Be deliberate and focus on each stroke. Turn your tile as you work to make it easier to create your design. Not every section of the string has to be filled with a tangle. If instinct tells you to leave an area blank, then follow your gut.

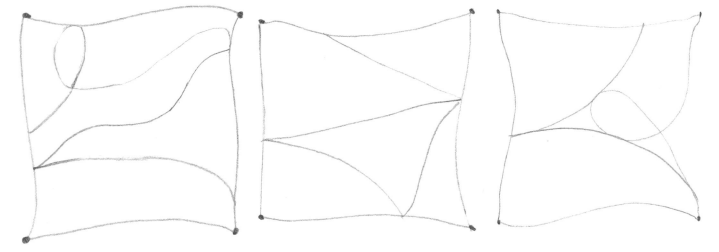

▲ *Steps 4 through 6 are spontaneous and generally created quickly. Like fingerprints, no two strings should ever come out the same.*

8. With your 2H or 2B pencil, shade your tangles. In the beginning, we shade the tangles by using the side of the pencil around the edges of each tangle then smudging it with our finger. This type of shading should be darker at the tangle edges, lightening as it moves away from the tangle. Shading is not effective if the whole piece is gray.

9. Once again, turn your tile and view it from each angle. Decide how you wish the piece to be viewed. Using the Micron 01 pen, place your initials on the front of the tile. Turn the tile over and sign your name and date the piece. You may add any comments here, like where you were, with whom, or if it is a particular event that day that this Zentangle honors.

10. Reflect on your piece of art.

11. Appreciate and admire your piece, not just up close but also from 3' to 4' (0.9 m to 1.2 m) away. It is amazing how the piece changes from a distance.

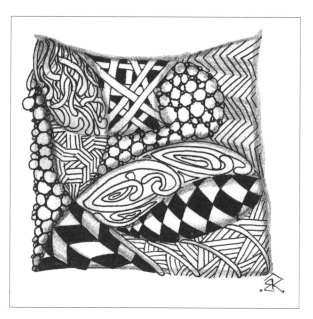

▲ *Shading only adds to the design if there are tonal contrasts between shaded and nonshaded areas.*

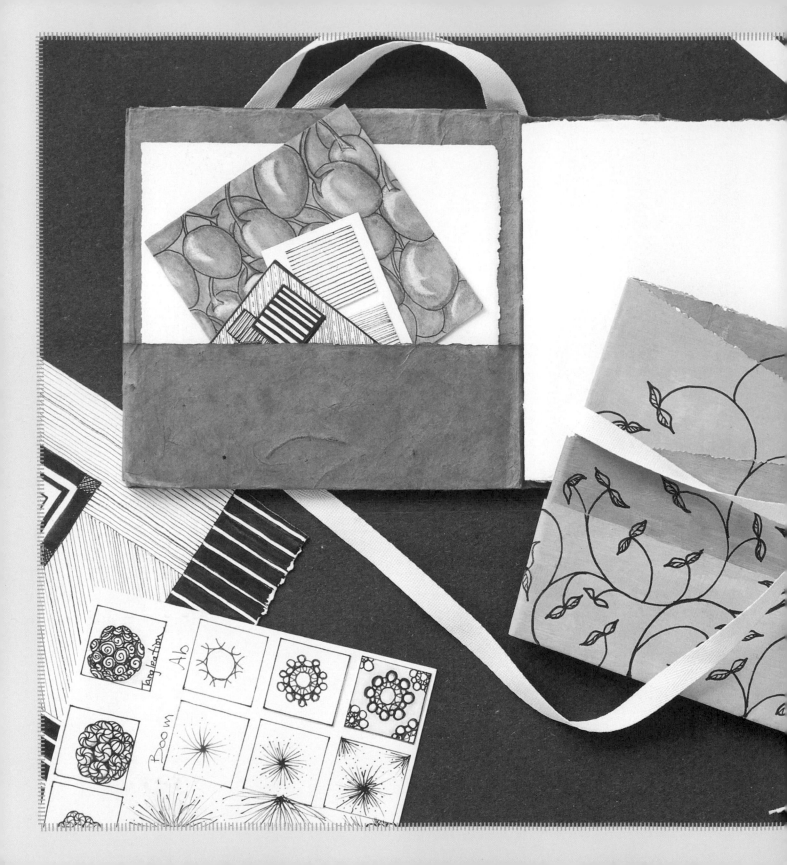

The Value of Line

From the first stroke of the pen until the last, our drawings are composed of lines. Tightening our grasp when using line to add texture, depth, and dimension to our artwork marks the beginning of our journey. To widen our artistic path we will explore the value of line to the artist, both literally and figuratively. We will experiment with altering lines and the effects those changes have on tonal values created in the process, while looking at the atmosphere, impressions, and moods line can create to enhance the message or meaning in our drawings. Paying attention to the characteristics of lines enables our art to draw in the viewer, direct them to what is going on in the piece, and allows them to take away their own impression, message, or story.

Make a Sketchfolio

This chapter's sketchbook has six pockets—
two pockets on the front cover and four inside.
The sketchbook itself is bound into the back of
the book using a simple pamphlet binding.

Materials

one sheet of Lotka paper, cut to 7½" x 30" (19 x 76.2 cm)

pencil

ruler

bone folder or wooden craft stick

tear bar, scissors, and/or a large paper cutter

two pieces of ½" (1.3 cm) ribbon, each 16" (40.6 cm) long

red liner tape or any extra-strong, double-sided tape (Note: This comes in various widths on rolls or in sheets; if using sheets, you will need two.)

one piece of two-ply chipboard, 5¼" x 5¼" (12.7 x 12.7 cm)

one parent sheet of drawing paper (I used Stonehenge Polar White), cut or torn into six 5" x 10" (12.7 x 25.4 cm) rectangles for the sketchbook and eight 5" x 5" (12.7 x 12.7 cm) squares for the art pieces

self-healing cutting mat

awl

14" (35.6 cm) length of waxed linen thread

binding needle or a size 18 tapestry needle

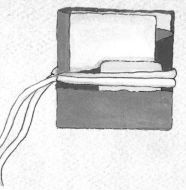

◀ *I call this book a* **sketchfolio.** *It is both a portfolio and a sketchbook.*

▶ *The dotted lines on the white sheet of paper (at right) indicate how the parent sheet is cut into sketchbook pages and art paper in the correct sizes.*

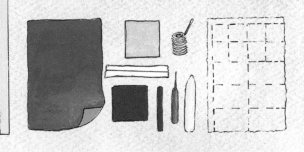

Instructions

1. Notice that one side of the Lotka paper is lighter in color than the other. Place the strip of Lotka paper on your work surface in landscape mode, with the color you want inside the sketchfolio face up **(A)**.

2. Next, fold a pocket that runs along the bottom of the sketchfolio. Mark a light, broken line across the bottom of the page 2" (5 cm) up from the bottom. Fold the paper on the line and burnish with a bone folder or a wooden craft stick.

3. Now divide the paper into six sections. Starting from the right-hand side, measure 5½" (14 cm) to the left and draw a faint, broken pencil line from top to bottom and fold on the line. Remember to keep the bottom edges even. Measure 5½" (14 cm) from the broken line you marked and make another faint, broken pencil line from top to bottom. Fold on the broken line, keeping the bottoms lined up as you fold. Repeat this three more times, always measuring 5½" (14 cm) over to the left of the last broken line you marked and folded **(B)**. Use the bone folder to burnish all the folds.

4. Open the paper into landscape mode with the exterior facing up. Measure 2½" (6.4 cm) up from the bottom on the right-hand edge and mark the spot. We are going to remove a triangular piece from the top of the first three sections on the right. Starting on the right, count over to the third fold. Place a ruler from the top of this fold to the mark you made 2½" (6.4 cm) from the bottom on the right-hand side. Draw a line, and then cut or rip along the line **(C)**.

5. The ribbons are attached approximately 1" (2.5 cm) past the first fold, in the second section from the left. Measure 2¾" (7 cm) up from the bottom on the first fold from the left. Use 2" (5 cm) of red liner tape to secure the end of one piece of ribbon by taping the ribbon in place. Place tape strips that are ½" (1.3 cm) wide in the areas shown in red in diagram C.

A

B

C

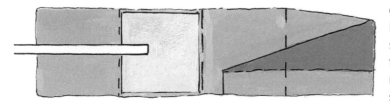

D

E

6. The chipboard square goes in the second section from the left. Place tape on the back of the chipboard, center it over the second section, and then set and press it into place. Tape 2" (5 cm) of the last ribbon on the top of the chipboard directly above the first ribbon. Remove the tape's protective covering from the first two sections on the right. Fold the first two right-hand sections over the third and fourth sections. Line up the bottoms and burnish them down with the bone folder. The cover now has four sections **(D)**.

7. Cover the chipboard and ribbon with tape. Take the second section from the right and fold it over the chipboard with the bottoms lined up, and then tape into place **(E)**.

8. The cover is finished. Fold the book shut.

9. The outside front cover has two pockets. The bottom pocket is perfect for meditative tiles, and the second can house 5" x 5" (12.7 x 12.7 cm) pieces of drawing paper **(F)**. When you open the book, there are two pockets for 5" x 5" (12.7 x 12.7 cm) drawing sheets **(G)**. Turn the page and you have arrived at the last section, which has two pockets. This is the section that the sketchbook will be sewn into **(H)**.

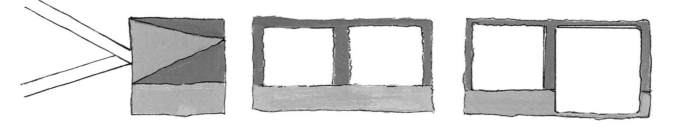

F G H

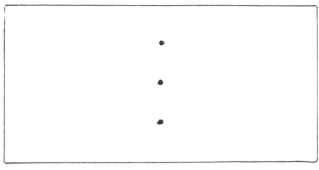

I

J

10. Place the 5" x 10" (12.7 x 25.4 cm) sketchbook pages in front of you in landscape mode. Individually fold all six pages in half and burnish the fold with the bone folder. Open up one of these pages and, using a ruler, measure up from the bottom and mark a dot on the fold at 1" (2.5 cm), 2½" (6.4 cm), and 4" (10.2 cm) **(I)**. Place the page flat on a self-healing cutting mat with the marked and folded spine facing up. Use the awl to make a hole into the spine on each dot. Line up a second page under the first and, using the first page as a guide, push the awl through the holes in the first page and create the binding holes on the second page. Continue using the first page as the guide and punch the three holes in the folded spine of the last four pages.

11. Place the cover on the mat. Open to the last section, and center one of the sketchbook pages onto the fold of the cover. Use the awl to punch the holes into the folded spine of the cover **(J)**.

12. Refer to the instructions for the pamphlet stitch on page 135 and sew your sketchbook and cover together using the waxed linen thread and binding needle.

It All Starts with a Line

▲ *The string was drawn using all straight lines at various angles.*

Line gives the artist the power to speak through visual storytelling.

It is the primary element of sketching, drawing, and tangling. An artist may use a line's variations and physical characteristics for self-expression. Line can imply meaning or action; set a mood; and create depth, contour, pattern, tonal values, or boundaries. In this lesson we become familiar with line and rectilinear forms.

Practice drawing straight lines in your sketchbook section of your sketchfolio. Continually turn the paper so you can draw toward yourself. Create both vertical and horizontal lines. Focus on achieving even, 90-degree angles. Rectilinear forms such as triangles, squares, and rectangles are created from straight lines placed together at various angles.

Materials

drawing pens in several size nibs (I used Marvy LePen Technical Drawing Pens and Zig pens)

sketchfolio (page 14)

meditative tile

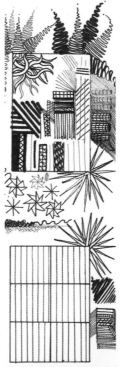

◄ *This piece was drawn with Zig drawing pens, sizes 003, 005, 01, 03, 05, and 08. Curvy, linear lines were also used on this page.*

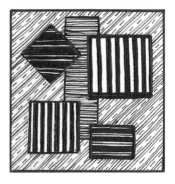

▲ *Ink, nib size, and the density of the lines within an area affect that area's tonal value. The shapes recede or ascend based on the tonal value inside.*

◀ *A helpful tip for creating straight lines is to place a dot where you want the line to start and another where you want it to end, then connect the dots.*

◀ *In your sketchbook, create a few linear tonal charts. For each pen nib size, create a box. I used Marvy LePen drawing pens.*

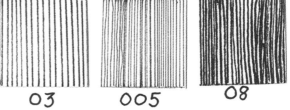

▲ **Linear tonal chart** *with various widths of line and spacing*

The spacing between the lines above is kept equal in order to keep the tonal values accurate. Notice that the smaller the nib, the lighter the tonal value created by the lines in that box.

Notice that the lines in the second square above are created with a smaller nib than the first square, yet it appears darker because the lines are closer together.

◄ *Keep the shapes at a moderate size. Too large, and you will have too few planes; too small, and the piece can easily become too busy.*

Line art is a drawing consisting of straight or curved lines on a plain background with no shading. They are achromatic (in black, gray, and white) or monochromatic (all in one color). Tonal values are achieved by varying line width and spacing in combination with solid pigment, background color, dots, or broken lines. Thin lines can imply delicacy or can create depth by implying the line is receding. Thick lines give an impression of strength and security. They appear to come forward to the viewer.

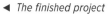 *The finished project*

On one 5" x 5" (12.7 x 12.7 cm) piece of sketchbook paper, create a drawing composed of rectilinear forms and linear tonal shading. Use a pencil to lightly draw out the rectilinear forms and shapes. As you progress, these lines will fade away like the string on a Zentangle. Use a drawing pen to fill each form.

Decide on a focal point. The focal point should appear the closest, so its tonal value is the darkest. The tonal values of all the other shapes should lighten as they move farther away from the focal point. Listen to your instincts and intuition. Refer to your sketchbook and your linear tonal value chart.

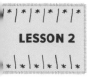
The Expressive Line

▲ *2" (5 cm) meditative tile with Spiteria and Protection tangles*

The meditative tile used for this lesson is a 2" x 2" (5 x 5 cm) tile. I can easily get lost working on the 3½" x 3½" (9 x 9 cm) tiles and spend more time than allotted for the meditative tile. The smaller tile is just the right size to allow my mind to slip into a higher state of focus and can easily be done in twenty minutes.

Materials

drawing pens in 003, 005, 01, 02, 03 (I used Marvy's LePen Technical Drawing Pens)

sketchfolio (page 14)

meditative tile (2 x 2 [5 x 5 cm] or 3½" x 3½" [9 x 9 cm])

The meditative tile teaches us to work with instinct, intuition, and knowledge when creating a tile. Just as we bring tangles or repetitive patterns from the tile to our artwork, we also want to work with instinct, intuition, and knowledge when creating art. Listen to your inner message and instincts, and then apply your knowledge, tips, and techniques to express yourself more clearly.

As visual artists we communicate by manipulating the drawn line. For the line to suggest to the subconscious, the line must be appropriate for the image. Thick straight lines give a sense of stability, while thin curvy or broken lines suggest an elegant, delicate, or frail nature. Lines that suggest movement, such as a closed coil are visually entertaining and stimulate the subconscious.

◀ *A 003 nib pen was used first to draw the squares.*

In your sketchbook create some 2" (5 cm) squares. In each square, create a line drawing using a line suited to the chosen tangle. Alter the line used to achieve depth. Listen to your instincts and intuition and be open to the possibilities.

On the first square (upper left), Bend was drawn with a 03 nib, and Continuity with a 005 nib. Bend's solid color helps it appear in the front. Square 2 (upper right) uses the tangle New Life. Areas intended to appear on top were drawn with a 01 nib, and the rest with a 005 nib. Rounded areas are colored black at the bottom and crosshatched on top, achieving a lighter effect and added depth. The depth of square 3 (lower left) comes from drawing the bottom tangles with a 01 nib, and then a 02 nib was used on the side of each stroke closest to the viewer. The top is drawn with a 005 nib, which is enhanced with a 01 nib. The last square's depth comes from the densely drawn bottom while the top is open and airy.

Technical Pen Strokes and Patterns

▲ *2" (5 cm) meditative tile with Scholar and Joyful tangles*

This tile's depth comes from the dark background and by using a smaller pen nib for drawing the background of Scholar.

Materials

drawing pens in several size nibs (I used Marvy's LePen Technical Drawing Pens)

sketchfolio (page 14)

5" x 5" (12.7 x 12.7 cm) sheet of drawing paper from your sketchfolio

Artists use repetitive pen strokes to bring interest, tonal value, depth, and shadows and to create an environment, set moods, and suggest ideas to the viewer. They can be used in a background to suggest shapes in the distance, to add a midtonal area to create movement, or applied on a focal point to add volume, weight, and shadows.

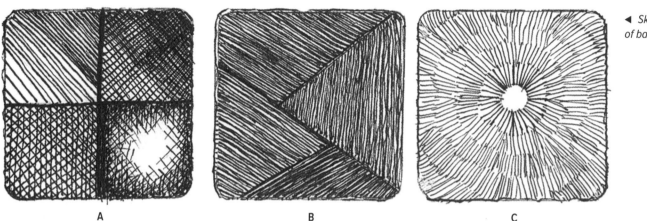

A B C

◄ *Sketchbook page of basic pen strokes*

From the time artists first picked up a pen, they have been using basic pen strokes to develop their drawings. The three examples here can be found in illustrations throughout art history.

Diagram A has four examples of crosshatching. The first quarter is done using parallel lines in one direction; the second quarter (clockwise) is cross-hatched with diagonal lines from the left and right—the denser the lines, the darker the pattern becomes. The third is crosshatched from both sides and verti-cally, and the last quarter has graduated crosshatching. The closer together the hatched lines are drawn, the darker the tonal value. Diagram B suggests the tangle Etch. The pen strokes used in this pattern resemble the strokes used on engravings or etchings. Diagram C radiates circles of lines. This look is most successful when the strokes are evenly spaced. Practice these pen strokes in your sketchbook to become familiar with them. When you feel ready, create a drawing on a 5" x 5" (12.7 x 12.7 cm) sheet of drawing paper and incor-porate a few of these pen techniques to bring these tangles to life.

◄ *Drawing of Energy and a new, reticulated, round tangle*

On Energy, I used pen strokes reminiscent of etched patterning. An open, radiating circle created from curved lines appears in the background.

Woven, Curved, and Stippled Pen Strokes

The pen strokes focused on in this lesson add texture and depth. They capture the user's subconscious and pull the viewer into an art piece.

Materials

drawing pens in several size nibs (I used Marvy LePen Technical Drawing Pens)

sketchfolio (page 14)

5" x 5" (12.7 x 12.7 cm) sheet of drawing paper from your sketchfolio

▲ *Tangles and tangelations of Texzen using woven, stippled, and entwining lines were created with 003 and 03 drawing pens. The broken lines created with the 003 pen appear gray and fall to the background, popping the areas with the 03 pen.*

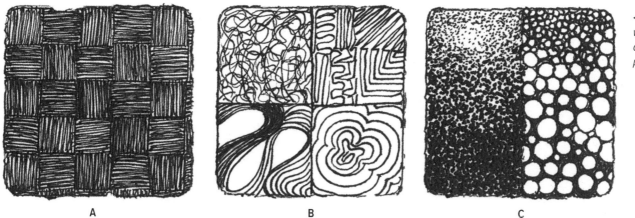

A B C

User-friendly and easily controlled, these strokes are an important tool for all artists. Throughout art history, these pen strokes have been used by calligraphers, illustrators, mixed-media artists, and—yes—even tanglers.

The tangles Keeko, Tipple, and Mooka (found in *One Zentangle a Day*) are composed of these basic pen strokes, as well as Strength, Bend, and Mak-rah-mee.

The density of the lines determines the tonal value of the pattern you are drawing.

Keep a scrap of paper close by when drawing so you can test the spacing of lines for the tonal value you desire.

Diagram A is a weave pattern reminiscent of the beginning of Mak-rah-mee. This look is most successful when the strokes are evenly spaced, which also keeps the tonal patterns even. Diagram B's first section is a scribbled line that is useful for adding texture or pattern or transitioning areas from dark to light. The second quarter (clockwise) is a reticulated scribbled pattern; this style is interesting and versatile. The third quarter is an example of lines entwining and merging. Many tangles take advantage of this pen stroke. The last quarter starts much like a closed coil; midway it changes to a radiating pattern of auras that go to the edges. Diagram C's first half is stippled heavier on the bottom, graduating lighter to the top. A useful tip is to stipple the pattern for the lightest area all over the surface, and then work in the darker areas. The second half is filled with circles. Light orbs contrast against the dark background and create movement for the eye. Practice these pen stokes in your sketchbook to get familiar with them. When you feel ready, create a drawing on 5" x 5" (12.7 x 12.7 cm) sheet of drawing paper and incorporate a few of these pen techniques to bring these tangles to life.

These pen strokes work to enhance both geometric and organic designs.

Irregular and Symmetrical Strokes

▲ *Curvilinear lines were used not only to create the form of the tangle Happy, Happy, Happy, but they also formed the patterning inside the tangle. In contrast, I chose the straight and angular tangle Nekton, (which can be found in* One Zentangle a Day*), drawing with a smaller nib so it would "pop" and direct the focus to tangled areas of Happy, Happy, Happy.*

Irregular and symmetrical pen strokes capture the attention of the viewer and can bring a great deal of depth to our art.

Materials

drawing pens in several nib sizes (I used Marvy Technical Drawing Pens)

sketchfolio (page 14)

5" x 5" (12.7 x 12.7 cm) sheet of drawing paper from your sketchfolio

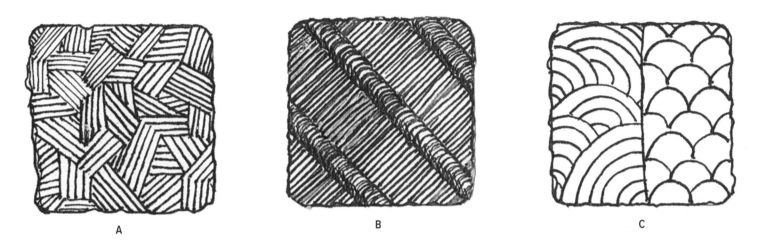

A B C

▲ *Diagram of one irregular weave pattern and two symmetrical pen strokes*

Equally effective on focal pieces as well as foreground and background areas, we can count on these pen strokes to liven up our drawings. As tanglers we were introduced to these pen strokes in the tangles Nekton, Tagh, and Shattuck, which are covered in *One Zentangle a Day*.

These pen strokes are an important tool to the artist. They allow the artist to bring interest, volume, depth, and movement to their work.

These pen strokes create instant depth and texture owing to the nature of how they are drawn. They are also very suggestive. Diagrams A and B remind me of textiles or a woven mat, while diagram C brings to mind waves, scales, or seeds on a pod.

Diagram A is an irregular weave pattern. This pattern is most effective when the spacing between lines is even. Irregular spacing can lead to an unorganized area that appears busy and stops the movement of the eye. Diagram B is an example of symmetrical weave. This example uses both curved and straight lines together successfully. Diagram C has two examples: the first is of circles, the second of scales. The concentric circle can be found in textile patterning throughout art history and always has been very popular in Japanese artwork. The last half of diagram C is a scale pattern. This repetitive pen stroke is limited only by your imagination. Practice these pen techniques in your sketchbook until you feel familiar with them. Next, on a 5" x 5" (12.7 x 12.7 cm) piece of drawing paper, create a design from two or three tangles and enhance them with both irregular and symmetrical pen stokes.

Tangleations

▲ *2" (5 cm) meditative tile with the tangle, Strength. All the shading on this tile was done with basic pen techniques and a 003 nib pen.*

Materials

drawing pens in several size nibs (I used Marvy Technical Drawing Pens)

sketchfolio (page 14)

2" x 2" (5 x 5 cm) tile

▶ *A sketchbook page of tangleations of Energy and Texzen : Pick a tangle and create a page of tangleations in your sketchbook. Use these tangleations to create two to three 2" (5 cm) tiles on a sketchbook page.*

Tangleations are versions of a tangle that are created by making some slight changes to the original. Changes can be made in shape, tonal value, using only one section, or adding sections. The possibilities are endless.

Added facets and hatched lines drawn in several sizes of nibs give more depth to Energy. Texzen was made into a border, with a frame of four triangles and a medallion. Tangleations give us the opportunity to alter tangles to fit the needs of our drawings. Use the tangleations to create several small tiles or one larger 5" x 5" (12.7 x 12.7 cm) art piece.

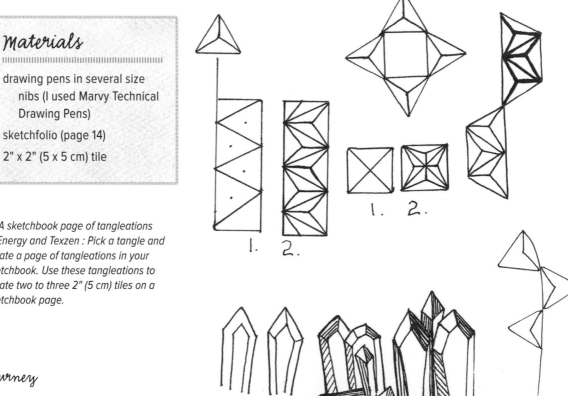

▲ *2" (5 cm) tile with tangleations of Energy and Abi*

▲ *2" (5 cm) tile with tangleations of Energy and Expanding*

▲ *2" (5 cm) tile with tangleations of Texzen*

The first tile (above) is a line drawing of the tangleation created from Energy. The tangle has been shaded with a 003 nib pen and sidehatching. The second tile also uses the tangleation for Energy and the tangle Expanding; both hatching and stippling were used for shading. The last tile was created using tangleations from Texzen. The original tangle is present in the four small medallions. Tangleations were used to create the center medallion—the four triangles that create the frame and the border. Radiating lines were added for depth as well as graphite shading.

Becoming "Plein Air" Aware

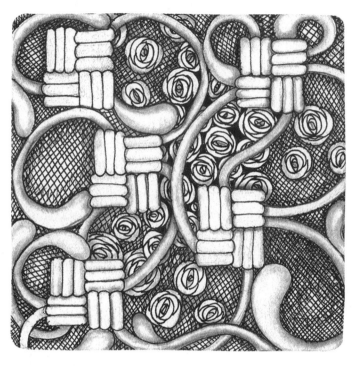

▲ The tangle Mak-rah-mee is the string in this tile. Michele created a new tangle by combining parts of the tangles Keeko and Mucha.

Materials

005, 01, 03 drawing pens (I used Marvy LePen Technical Drawing Pens)

2B pencil

sketchfolio (page 14)

tortillon

camera (optional, but handy for capturing inspiration and patterns for future inspiration)

two or three 2" x 2" (5 x 5 cm) tiles

In this chapter we've been rethinking and transforming line and patterns to create new tangleations.

This lesson is about the next step—finding inspiration and creating your own tangles. For centuries artists have heightened their skills by working *en plein air*. This French phrase means "in the open air." Artists are drawn to create en plein air for the benefit of drawing in natural light and to finding inspiration outside of their studios. Drawing teaches us to take a closer look at the world around us, to see objects in greater detail. Plein air artists study the positive and negative shapes, patterns, designs, textures, colors, highlights, and shadows in natural light and come away with a more intimate appreciation of the objects and forms they portray. I recall the places and things I have created en plein air while traveling far more than those I just photographed. For this exploration, there is no need to travel far. Gather the items in the materials list and venture out to your own backyard, a neighbor's garden, or a local museum or coffee shop. Document and step out the tangles you find along the way in the sketchbook of your sketchfolio.

▲ Usually flower blooms do not make great tangles because they are recognizable, but there are exceptions to the rule. This flower does not have the standard petals, and the resulting tangle (Boom) does not read as a flower.

▶ Sketchbook pages of new tangles based on the flowers and buds above

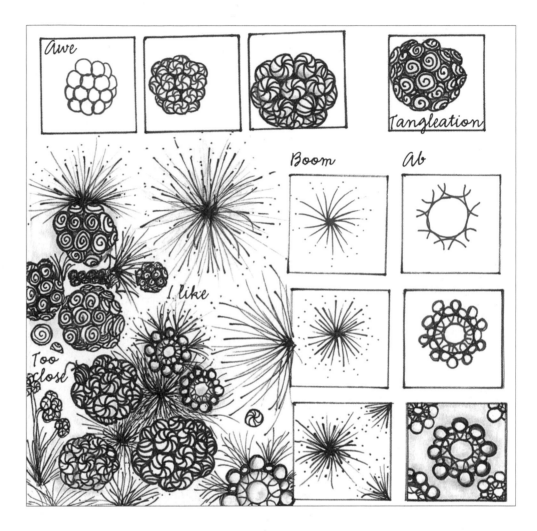

Here are a few tips and reminders.

1. Tangles should be able to be drawn in just a few steps.

2. Tangles should be drawn using only a pen. No rulers or pencil guides are needed.

3. Tangles should be abstract, repeatable patterns that are non-representational. The idea is to focus on the repetitive stroke, not on drawing a leaf or flower.

4. Tangles should be nondirectional; they have no up or down, right or left.

Tangled, Emulated, and Colored

ZENTANGLE-INSPIRED ARTWORKS

Our journey continues by diving into the world of Zentangle-Inspired Artworks, commonly called ZIAs, which refers to art that contains tangles within its design. They can be created with any medium, contain color, be any size, and on any substrate, making ZIAs perfect for mixed media. We will create personal road maps of our tangled journey and explore new paths to rethink the way we see and use our favorite tangles, and then continue on to identifying and creating tangles of our personal journeys. Next, we'll explore breaking down objects into easily drawn, simple shapes to integrate into our ZIAs, and then proceed to cover and/or surround them with tangles. Mixed-media techniques for coloring our ZIAs on paper and fabric will brighten our path as we continue to explore our world, finding inspiration.

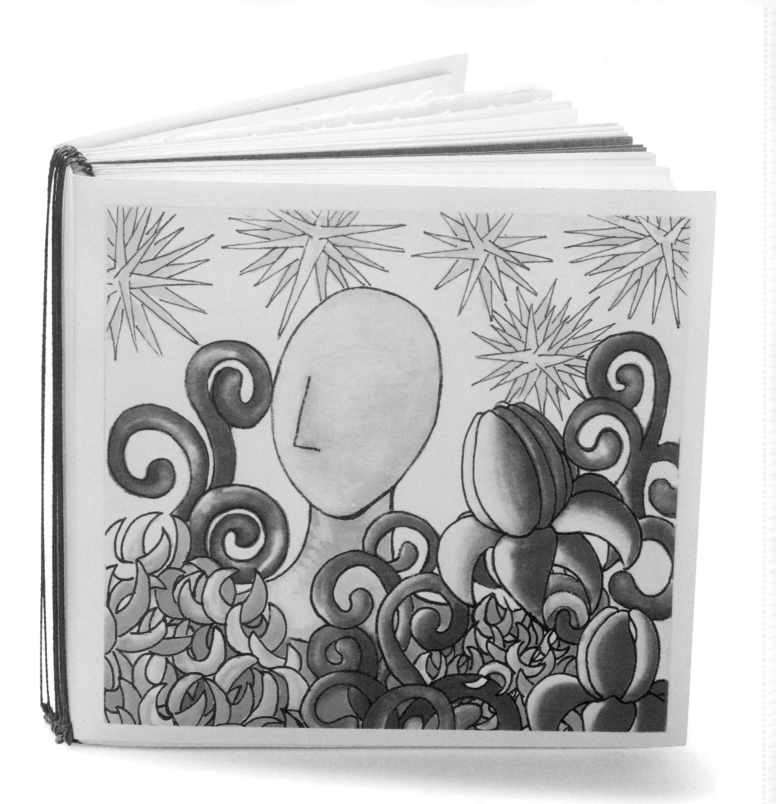

Knotted Sketchbook

Materials

two pieces of freezer paper, 4" x 8" (10.2 x 20.3 cm)

two pieces of white cotton for the fabric pages,
 4" x 8" (10.2 x 20.3 cm)

iron

fourteen pages for signatures, 4" x 8"
 (10.2 x 20.3 cm) each

bone folder

seven rubber bands or elastic cording (see A, page 38)

seven pieces of 2-ply waxed linen thread or 10 lb
 hemp cording, each 16" (40.6 cm) long

one piece of drawing paper for the cover sheet,
 4" x 10" (10.2 x 25.4 cm), to be trimmed
 during binding

ruler

scissors

glue

Instructions

1. The freezer paper stabilizes the fabric pages as we draw on them. Place the shiny side of the freezer paper next to the fabric and iron a piece of freezer paper to one side of each piece of fabric. Fold the fabric page in half crosswise, freezer paper on the inside and fabric on the outside; iron the crease. Place one fabric page inside the other to create a fabric signature and set aside.

2. Fold the cut paper signature pages in half crosswise and burnish the fold with a bone folder.

3. Collate two or three paper pages together for each signature.

A

4. Some of the mediums we use require drying time. I recommend temporarily binding the signatures with rubber bands or elastic cord while working on the lessons and binding them together at the end of the chapter. On 4" (10.2 cm) signatures, #33 rubber bands work great **(A)**.

Binding the Book

1. Leaving a 4" (10.2 cm) tail at the top of each signature, place a piece of waxed linen in the center of each signature **(B)**.

2. Binding from right to left, place the first two signatures side by side, aligning the spines. Tie both 3" (7.6 cm) pieces of linen at the top in a square knot (see page 134) **(C)**.

3. Next tie the two strings of linen at the bottom of the signatures with a complete surgeon's knot (see page 134). Be gentle when pulling the knot into place on the bottom edge of the two signatures so you don't bend or damage the paper.

4. Pick up another signature and place it to the left of the second signature, aligning the spines **(D)**.

5. Tie the two 3" (7.6 cm) pieces of linen from the second and third signatures at the top in a square knot.

6. Tie the strings at the bottom of the second and third signatures in a complete surgeon's knot.

7. Attach the remaining signatures as you did in steps 4 through 6 **(E)**.

8. Measure the combined width of the front signature, spine, and back signature, add ¼" (6 mm) and trim your cover to that measurement. The height is the same as the pages' height. Cut the cover from the paper of your choice.

9. Measure 4⅛" (10.5 cm) from the left side of the paper and score a vertical line with the bone folder. Measure 4⅛" (10.5 cm) from the edge of the back cover and score a vertical line. Fold and burnish the vertical lines with the bone folder and place the cover around the book block **(F)**.

10. Bring the thread at the bottom of your first signature over the outside of the signature's spine to the corresponding 3" (7.6 cm) tail at the top of the first signature and tie with a square knot **(G)**.

11. Repeat step 10 for the remaining six signatures. When you have tied the tail end at the top of the seventh signature, your book is bound **(H)**.

12. Place a drop of glue on the top of the knots on the top, and trim the cords when the glue dries **(I)**.

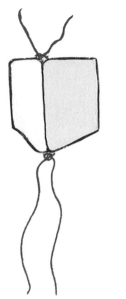

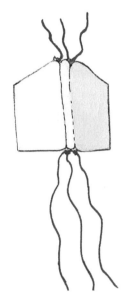

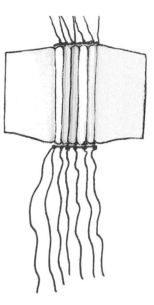

B. *Waxed linen placed in a signature*

C. *First two signatures tied together*

D. *First three signatures tied together*

E. *All seven signatures tied*

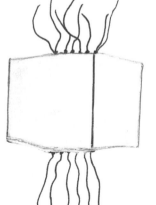

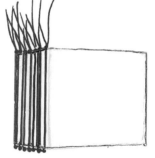

F. *Scored cover*

G. *Step 10*

H. *Book block with all seven tails tied*

I. *This book is quick to make, and the exposed spine on this book gives it a classical look.*

Shape Shifting for a Change in Perspective

▲ *Single hexagon tile*

I find it is good to change things up every once in a while to expand my horizons. In this lesson we are changing up the shape of our tiles or drawing paper. Our goal for this lesson is to see new opportunities in our designs, ignite intuition and instinct, freshen our tangling, and rekindle the muse within. The hexagons in this lesson were created with punches that come in three sizes.

▶ **Ensemble made from hexagons**
Hexagons are a fun shape and can be drawn on singularly or fit together to create an ensemble. This ensemble was created from four small and four large punched hexagons.

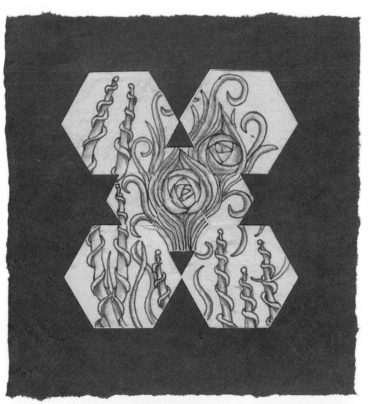

Materials

pencil

drawing pen (Marvy LePen Technical Drawing
 Pen or Zig pen)

knotted sketchbook (page 37)

punches or scissors to cut shapes

Artist Angie Vangalis agrees that shifting our perspective can be very helpful. She shares the following lesson not only to keep us from getting into an art rut but also to help prevent or end mental blocks.

• Using different shapes for your artwork can take your journey to a new level, like looking through a different lens—a sense lens.

• Looking through a "sense lens" means looking at a situation with a different creative perspective from which your creativity can grow.

• Different types of sense lenses or filters can use sound, taste, smell, and touch instead of sight. This technique is particularly helpful in working through mental blocks.

For example, if you were having a mental block because you are not motivated, you might ask yourself, "What does motivation smell like? What does motivation taste like? Sound like? Look like? Feel like?" Using other senses may sound a bit crazy, but looking at the old perspective in a different way can be the key to moving your creative spirit.

Another way of using the sense lens technique can be through association. Associating these senses with basic life-sustaining principles, such as service, gratitude, balance, and intuition, can help generate a different thought process. Simply changing the way you look at how you produce your art can help jump-start your creative juices, especially if you are stuck in a rut.

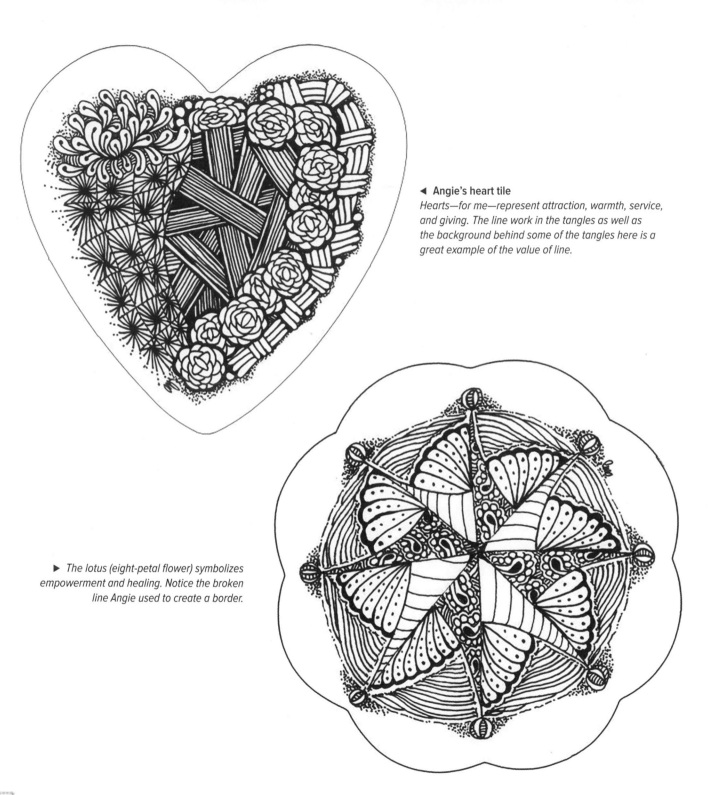

◄ **Angie's heart tile**
Hearts—for me—represent attraction, warmth, service, and giving. The line work in the tangles as well as the background behind some of the tangles here is a great example of the value of line.

► *The lotus (eight-petal flower) symbolizes empowerment and healing. Notice the broken line Angie used to create a border.*

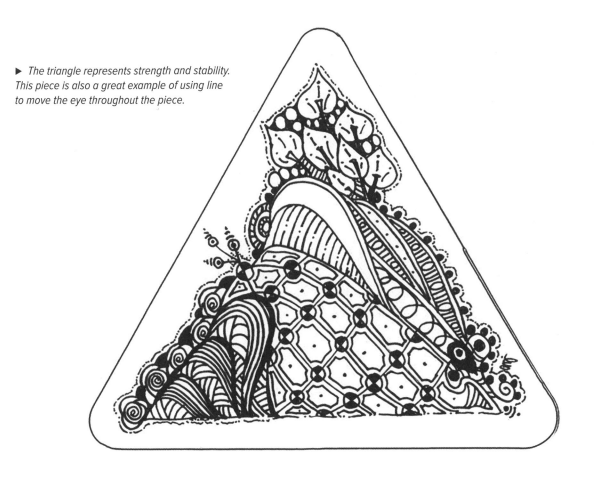

▶ *The triangle represents strength and stability. This piece is also a great example of using line to move the eye throughout the piece.*

I have an attraction for hearts, lotus flowers, and triangles not only because they are different than a traditional rectangle on which to produce artwork, but for the positive associations with those shapes.

I set out to create my marks using a different perspective and an open mind, simply creating according to how it feels using my intuition and inspiration throughout the process. The end result is usually a surprise. Use these shapes or one you prefer to create Zentangle-inspired artwork. Keep the work to 6" (12.7 cm) or smaller.

Fountain Pen Fun

▲ *Dreamt, Fluffoff, and Noknot, all by Sarah Hodsdon, based on patterns recalled from her childhood home*

Materials

fountain pens and ink (I used Noodler ink and pen and Straedler pen)

scrap paper

knotted sketchbook (page 37)

one piece of 5" x 5" (12.7 x 12.7 cm) drawing paper

Fountain pens are a favorite drawing tool of mine (and many others, too), and ink for these pens come in every color possible.

The lines created with one have a distinct look, paper seems to glow through transparent inks, and opaque inks seem brighter on the page. Going over the areas you want to appear shaded will darken the area and give the effect of shadows. Fountain pens and inks come in a wide range of quality. I recommend using a pen with an ink cartridge or ink bladder that is fillable so that you can be assured of color consistency throughout the project; ink cartridges, on the other hand, hold very little ink. Buy enough cartridges to get through your project. If you run out during a project, a new cartridge might have a different shade of ink. If possible, first try out the ink and pen you are planning to buy. The pens are available with flexible or nonflexible nibs; flexible nibs allow a slight variation in line width as you draw. To achieve line variation with a nonflexible nib, change the angle at which you hold the nib.

Use scrap paper to test your pen's ink flow before starting on your sketchbook page. Learn a few new tangles as you practice drawing with your pen in your sketchbook. Use your instinct and intuition to develop a drawing from the patterns created as you practice.

Three pens and mixed-media drawing paper were used for this lesson. The orange ink was placed in a fine-tip 005 nib, the black used a 02 nib, and the brown a 06 nib. The ink was slower to dry than the ink found in drawing pens, so caution is necessary when working in small areas. Going over an area that is still wet can oversaturate the paper and lead to the ink bleeding.

▶ *A fine tip and a medium tip were used in this black-and-white sketch with the tangle Noknot.*

When you are comfortable with your pen, it is time to create an art piece on the 5" x 5" (12.7 x 12.7 cm) paper. Keep it small so that you finish quickly. You can begin it as a planned drawing or just start and let the piece develop as you draw.

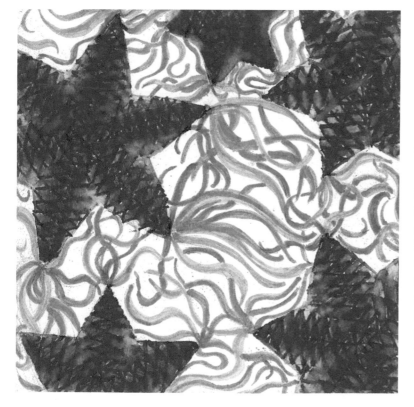

I started this (left) piece without a plan. I first drew the Texzen patterns with a fountain pen and orange ink. I added the chevron pattern to their interiors, starting in the center with red ink and changing to orange on the outsides. The red chevrons were colored in orange, the orange ones in yellow, and the yellow pen was used to blend the pieces together. Once dry, I changed to a slightly larger nib and green ink to draw the tangle Bend.

Identify, Break Down, and Create Tangles and Emulations

There are days when unplanned patterns will flow out onto the paper one after the other, and then there are days when only the tried-and-true comes to mind.

▲ *All tangles break down into theses shapes.*

Patterns that suddenly appear in my work are often inspired by things I see or run into in my day-to-day life. The key is being aware. For those opportunities, there is always a small sketchbook in my bag or back pocket for making a few notes; in a hurry I even grab a picture on my smartphone. Inspiration often sparks our creative juices and takes our artistic style off in new directions.

There are not many rules for creating tangles. Patterns should break down into no more than a few steps, and you should be able to create them with only a pen or pencil.

Using your intuition, sketchbook, and pen, create a page based on one of the shapes that tangles break down into (see left). Try to re-see this shape, and notice how many patterns you can create from the shape.

Materials

drawing pen (I used Marvy LePen Technical Drawing Pens)

pencil

knotted sketchbook (page 37)

kneaded eraser

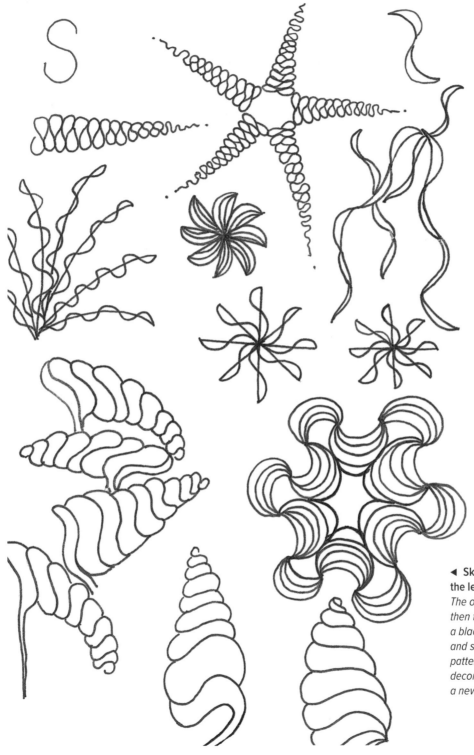

◄ **Sketchbook page of drawings using the letter S to create tangles**

The original S shape was drawn in red, then the pattern was built around it with a black pen. Just play with the shape and see where it leads. Some of these patterns use the S shape as is; others deconstruct and reconstruct the S into a new shape.

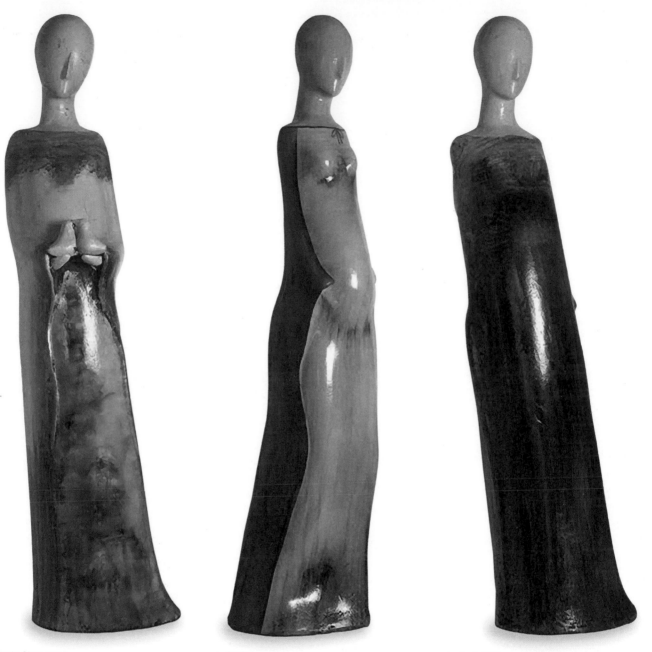

▲ *Lady Chenevert* ▲ *Lady Leona* ▲ *Lady Helena*

It is not just tangles that break down into common shapes; all objects evolve from simple shapes. Just as we break tangles into simplified shapes, we break down items we want to emulate in our art. When emulating, we do not worry about capturing an identical image, concentrating instead on capturing the essence of the image.

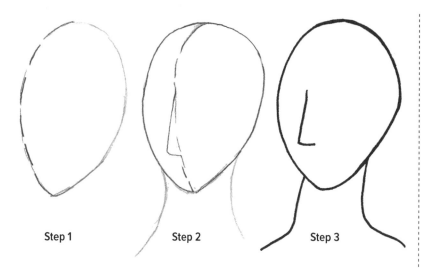

Step 1 Step 2 Step 3

▲ **Drawing Lady Chenevert's face**
When emulating, sketch the outline of the objects with a pencil first. Once the shape is refined, ink in the face and erase your guide marks.

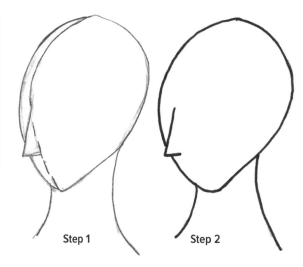

Step 1 Step 2

▲ **Lady Chenevert's head in a new position**
Using the same formula, I can draw the head correctly in any position.

Lady Chenevert, Lady Helena, and Lady Leona are statues in my studio that are easily emulated. Simple in stature, their message and mood relies on the position of the head and body.

Lady Chenevert's head appears to be egg shaped. That's true, but this doesn't help us in placing her nose or giving the impression of the depth of her head. Let's break it down further. Refer to the picture while drawing her head. For step 1, using a pencil, start drawing at the center, top of the head, following along the left side down to the chin. Step 2 starts at the head's top center. Draw the right half of the head to her chin. To place the nose, draw a dashed line from the center point at the top of her head that follows the contour of her face down to her chin. Place the top of her nose on the dashed line one third of the way down between the top of her forehead and chin. The bottom line of the nose should be halfway between the top of the nose and her chin. Step 3 shows the face inked over, my light pencil drawing and guide lines erased.

Using one of the images on page 48 for inspiration, create an emulated drawing of one of the ladies.

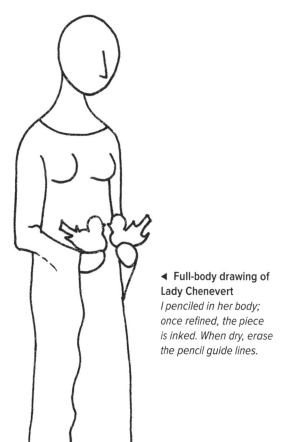

◀ **Full-body drawing of Lady Chenevert**
I penciled in her body; once refined, the piece is inked. When dry, erase the pencil guide lines.

Colored Pencils

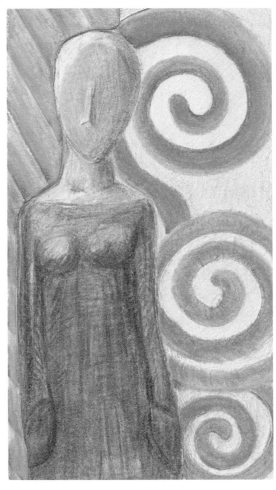

▲ **Mixed color pencil piece**
This piece contains each type of colored pencil, showing the diversity of textures that are available and that they all work together.

Artists have a wide variety of colored pencils to choose from, each with a unique feel and mark. There are two types of colored pencils: watercolor (or water activated) and dry-based pencils.

Several manufacturers now make their colors available as both types. Watercolor pencils contain watercolor or ink in the pencil core. Dry pencils are available as pastel, pigment-based, and oil-based. Pastel pencils are the softest, with a beautiful soft, chalky texture. Pigment-based pencils are soft, creamy, and easily blended. Several contain wax, which can be overworked, creating a wax buildup and leaving behind a wax bloom. The oil-based pencils are also buttery and easily blended. They do not contain wax, so there is no worry about too much wax. They develop nice stroke work into the surface as you build up layers.

The statue drawing at left, is done in oil-based pencils. The green coils are done with four colored–pigment pencils, but each is blended differently. The top coil is worked light to dark and colored in a circular motion, then blended with the lightest color. The colors were flicked onto the second coil, starting with the lightest and ending with the darkest. The last was colored and then blended with the blending pen, which also works on regular colored pencils. These techniques can be used with any type of colored pencil. The light blue background was created with watercolor pencils; extra-soft pigment pencils were used for the gray background.

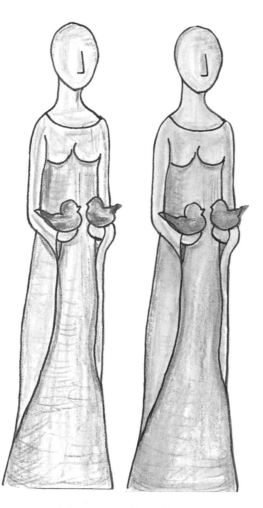

▲ *Inktense colored Lady Chenevert*

Notice that I have not colored the statue solidly with Inktense pencils, which contain water-soluble ink that is very saturated.

The colors become much darker when blended with either a brush and water, or a blending pen.

The piece above was blended with the Tombow colorless blending pen. I use these pens to blend all water-soluble pencils when I am looking for greater control than a brush and water provide. Work from light to dark; when the brush or blending marker appears dirty, stop, clean off the tip on scrap paper, and continue on.

▲ Zac's pencil drawing

▲ Zac's inked-in piece

Working with your instinct, intuition, and knowledge while creating will keep you in touch with your personal style. Emulating is all about bringing your own style to your art. Zac Thomas is an artist and friend who visits my studio. I asked him to do a colored-pencil art piece with Lady Chenevert.

Zac did not work from a picture but from memory. He began this piece by making a pencil sketch.

Zac decided where the light source was, and he marked where the shadows would lie very lightly with a pencil.

Next Zac used pens in various widths to create depth in the design.

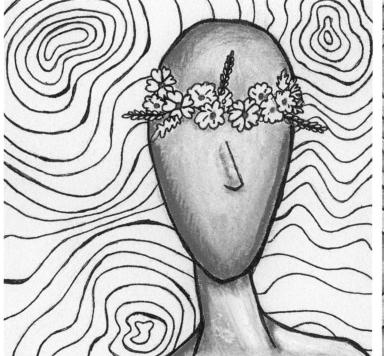

▲ *Zac's colored body*

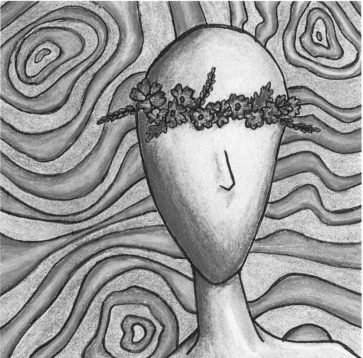

▲ *Zac's finished piece*

To color the figure, four Prismacolor (pigment) colored pencils were chosen. The entire skin area was colored in, beginning with the lightest shade. Zac continued to work away from the highlight, with three colors changing in the shadows; each color should appear darker but with less coverage than the previous one. Lighten pencil pressure where the opposing colors meet.

After all colors are in place, finish off with the blending pen, allowing the colors to meld together and create a gradual gradient between each. If needed, lightly add color to increase the color density.

The background was colored in with light blue and gray pencils. The blue areas were then outlined with dark blue pencil. True to Zac, this piece expresses his personal style.

Emulate one of the ladies or an object you would like to draw. Add the tangles to the object or the surrounding area. When finished, color using colored pencils of your choice.

Mixed-Up Markers

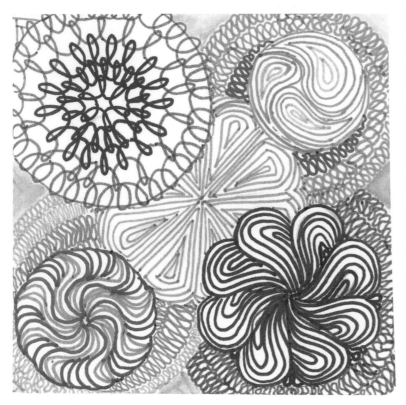

▲ Line marker drawing
A small set of markers offers enough colors to produce beautiful pieces. This line drawing was created with a set of twelve markers on an airport layover.

Markers bring color, mood, atmosphere, texture, and depth to a drawing.

Marker inks range from transparent and semitransparent to completely opaque. In this lesson, we will focus on water-based ink markers, alcohol markers, and acrylic paint pens to create a mixed-media marker art piece.

Although all of these are markers, the mediums inside each are different. Each type has a different look and unique qualities that bring atmosphere, texture, and finish to the piece.

Materials

alcohol markers (I use Chameleon Color Tones)

water-based paint pens (Tombow)

pigment ink drawing pens (Zig)

acrylic paint pens (Molotow)

blender pens

6" x 6" (15.2 x 15.2 cm) square of 140 lb hot-press
 watercolor paper

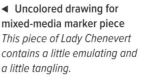
◄ **Uncolored drawing for mixed-media marker piece**
This piece of Lady Chenevert contains a little emulating and a little tangling.

1. Create a sketch to color.

To use some of these pens, your illustrations must be drawn with pigment-ink drawing pens; pigment ink will not run when alcohol pens color over it. If the drawing you would like to use was done with another type of ink, scan the drawing and print a laser copy onto the paper you are going to use. Feel free to design your piece with a light pencil drawing, then ink over the drawing and erase the pencil lines.

Take a moment to stop and plan how you want to color your drawing. When mixing markers containing different mediums, you need to know the characteristics of the marker's ingredients you have chosen and use them in an order so that areas already colored will not be disturbed.

Before coloring, I plan the order in which I will use the markers. I chose to use the alcohol markers for their transparency, ease in blending (without becoming heavy), and permanence once dry. Water-based paint pens were chosen for their brightness; however, when an alcohol marker goes over them, they can bleed or blend into the alcohol markers. Therefore, they need to be applied over the alcohol markers if they are used together. Paint pens were chosen to add opaque highlights and mimic the glaze of Lady Chenevert's skin. Markers applied over paint pens can have a different shade over the paint than the surrounding paper, which is not an effect I am looking for, so I will be applying them last.

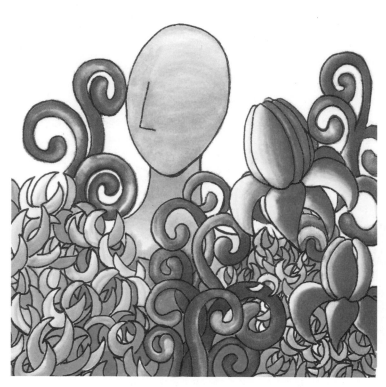

▲ *Water-based markers will not affect the alcohol ink, but the alcohol ink can cause the water-based pens ink to separate and blend if the alcohol ink is not dry before moving on.*

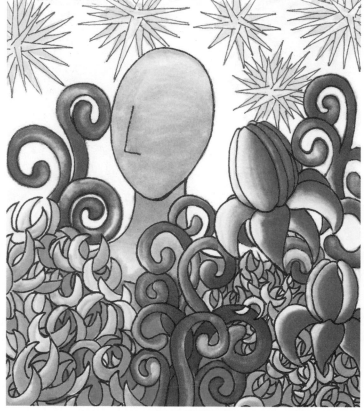

▲ *Worked from light to dark, the tonal values were built up gradually. Make sure the ink is dry before moving on.*

2. Begin coloring with the alcohol markers.

I decided to color the statue and organics with the alcohol markers; I decide on a light source from above, slightly to the left. Alcohol pens come in various strengths and should be applied from light to dark. My set comes with a medium chamber for each pen. I treated the ink like watercolor, working from light to dark and using light layers to build up the color shading. A blending pen was used to blend in the deeper high-lights and shadows.

3. Color in the areas using the water-based ink markers.

Before I began to color the sky, which is where I planned to use the water-based ink markers, I drew five little lanterns into the upper area. I used a blender pen, yellow and blue markers, and a palette to color in the yellow lanterns and sky. First, the yellow and blue markers were applied onto the palette. The blender pen was used to pick up the yellow color, testing it on scrap paper to check the shade, then I colored in the lanterns, light in the front and darker in the back. Then I cleaned the blending pen off on scrap paper, and picked up the blue with the blending pen and applied it to the sky area.

▲ *Finished Lady Chenevert*

4. Add the paint pens last.
Paint pens now come as water-based acrylics with drawing nibs. I used the paint pens to add an opaque finish to the highlights on the statue's skin and to add highlights in the sky. A soft brush was used to blend the edges out.

Painting Fabric while Maintaining Its Hand

Materials

Pentel fabric drawing pen

fabric sketchbook pages backed with freezer paper from the knotted sketchbook (page 37)

Tulip dye-based fabric markers

iron and ironing surface

fabric paint (I use Settacolor or US ArtQuest)

mixed-media pen (a fluid line writer)

distilled water

glue (I use US ArtQuest's Perfect Paper Adhesive [PPA] Matte medium)

paintbrush

palette

small container of distilled water for diluting paint and rinsing brush

Painting on fabric usually leaves the fabric stiff and hard. The fabric no longer flows or feels natural, which is called the "hand." In this lesson we will create on fabrics in two ways, neither of which will change the fabric's hand.

The first technique creates a two-sided painted fabric using ink and dye fabric pens. Tangle on the cloth side of the sketchbook page using the Pentel fabric pen **(A)**.

Next, color in the focal areas of your fabric with the dye-based fabric pens. Have a scrap of fabric close by to test the pen's color. When you're done coloring and the ink is dry, pull off the freezer paper from the back and fill in any areas that may require a touch up on the back side of the fabric. Iron the fabric to heat set the color.

The small piece **(B)** is an example of the front side of my finished sketchbook page. The large piece **(C)** shows the reversible back side of the fabric; it was actually the scrap fabric I tested my colors and pens on. I like how it turned out.

A. *Make sure the ink and fabric are dry before continuing on.*

B. *Finished small piece of two-sided fabric*

C. *Large sample of two-sided fabric*

▲ **Loading the pen**
Once you have familiarized yourself with this pen, it will become a favorite art tool.

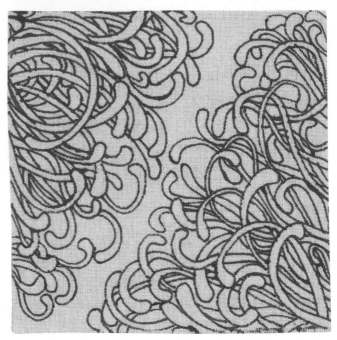

▲ *Fabric with red flowers*

The second technique requires the rest of the materials list. Place a quarter-size dollop of fabric paint on the palette. The paint needs to be the consistency of heavy cream in order to work in the mixed-media pen. Mix in distilled water to dilute it or the PPA Matte medium to stiffen. Once the consistency is ready, load the paint into the pen top using the brush. Test the pen on the palette. If the paint is dripping out of the bottom of the pen or runs out as you hold the pen, the paint is too thin. If the paint is not coming out when you try to draw across the palette, it is too thick; dump the paint, thin it, and reload the pen. Once the pen is flowing, draw your patterns onto the fabric. Let the paint dry, then iron the piece to set the colors.

Follow the manufacturer's directions for cleaning the pen after use; if you leave the pen loaded with paint when it's not in use, it can become clogged. The little wire tool that comes with the pen will remove any clogs. If you must leave a pen loaded for a while, avoid a clogged tip by setting the pen on a damp paper towel and covering the tool with another damp paper towel.

I love the coverage and control I achieve with the mixed-media pen. If your line is uneven or the pen is skipping, slow down—you are moving too fast.

▲ *Fabric with blue tangles*

I drew the graphics on this piece with the Fluid Writer Pen and then colored it with dye markers.

◀ *Fabric sample with blue and pink dye coloring*

This piece was created using acrylic paint on paper. The best part of this pen is that you can use any ink or paint in it.

◀ *Fluid Writer Pen paper piece*

Being Tangle Aware: From Neighborhood to Travels

There are tangles everywhere, and finding them is always part of my *plein air* adventures, whether it is a walk in my neighborhood or a trip of a lifetime. I most vividly recall the places, things, and patterns that I have seen in what I have drawn.

▲ *Chameleon pen study*

▲ *Spica pen study*

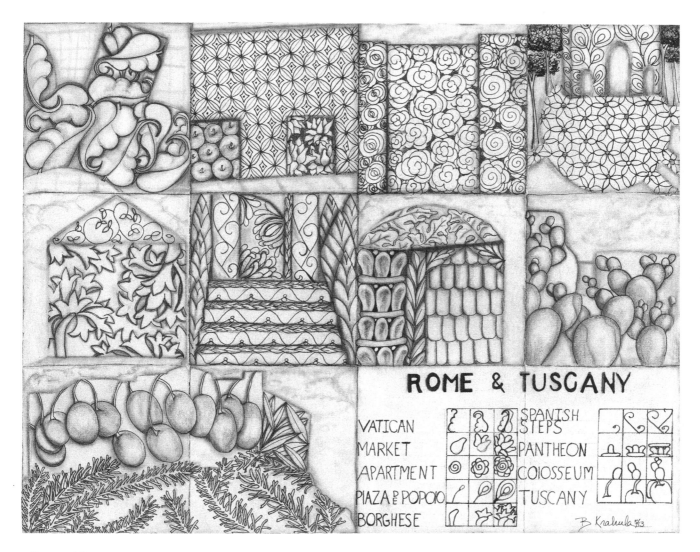

ROME & TUSCANY

VATICAN
MARKET
APARTMENT
PIAZA DE POPOIO
BORGHESE

SPANISH STEPS
PANTHEON
COLOSSEUM
TUSCANY

B. Krahula 5/3

▲ *Rome and Tuscany map*

Both pen studies (left) were created in my neighborhood. The small book used Spica pens. The larger drawing used Chameleon Color Tones alcohol pens with ink cartridges that enable each pen to produce multiple shades. The drawings are both tangleations from the tangle Verdigõgh, yet they look very different.

When traveling, I aim to fit some time in for plein air art, but if I am the only artist in a group, this can require being creative.

Before leaving home I cut Artistico hot-press paper into 16" x 16" (40.6 x 40.6 cm) pieces that were scored horizontally and vertically every 4" (10.2 cm) across and folded on the score lines, creating a map with sixteen tiles (above). The map folds to 4" (10.2 cm) square. On the trip I drew a string in the shape of the places I was visiting that day. Some were tangled on-site; for others I would snap a picture of the inspiration and fill in the tangles when time allowed later that day.

▲ **Spires of Praha**
The tangle inside each spire came from inside the building the spire was on.

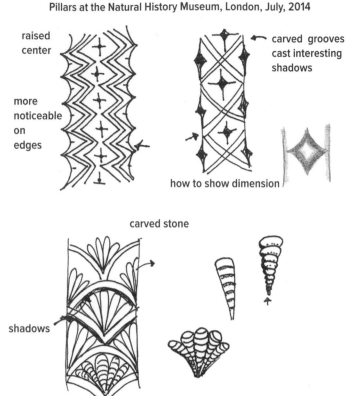

raised center

more noticeable on edges

carved grooves cast interesting shadows

how to show dimension

carved stone

shadows

▲ *Cris shares her sketchbook study of pillars from the Natural History Museum in London. Cris founded elements on the pillars that she realized were interesting, easily broken down, and had opportunities for adding personality to her tangles.*

This piece (above) was a 4" (10.2 cm) square tile I carried around Prague for a day. The city of spires soon turned into my muse, and the patterns I picked up there have appeared in many meditative tiles and ZIAs since my visit.

Cris Letourneau carries her sketchbook everywhere. There are so many ways to make these tangles your own. Here are several tips we consider when drawing tangles.

• Examine the pattern. Ask yourself what area is the most interesting.

• Evaluate how to break the design down to the basic shapes.

• Would this pattern work on a grid?

• As you draw, notice what may develop. Repeated patterning can open your eyes to a new design. Texzen (see page 141) came to me that way. I was actually drawing triangles divided into thirds; when I drew them in a circle, the result was Texzen.

• When drawing a new tangle, stop after three or four steps. Do not be discouraged; reevaluate for a simpler look and rework or simplify the design so you can finish it in three steps or fewer.

• Add auras, which are "halo-like" lines that trace around the outside of a tangled design. Perfs, (small circles), can be added to transcend or pull patterns together.

• Change (or add) lines for weight, fill, to darken or to lighten, or to give the tangle greater interest.

• Can you see this pattern used as a border, in the round, or with another shape?

• Do you see ways to create tangleations of this pattern?

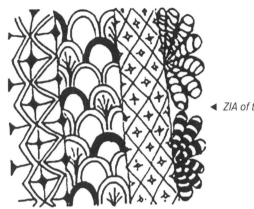

◀ *ZIA of tangles*

The best way to get familiar with a new tangle is to use it on a few tiles. In this tile, Cris's string is three lines of varying widths, giving us four "pillars" to tangle. Her examples show that there are many different ways to translate a pattern into a tangle.

Interesting effects can be created by enlarging and rotating various elements.

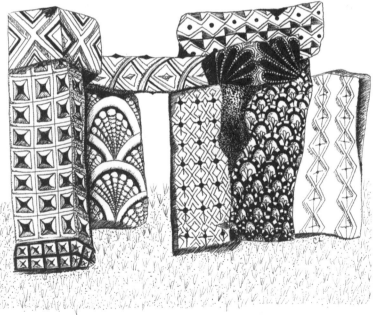

▲ *Cris's sketchbook notes were turned into two tangles later that day: Syl on the left, Faience on the right. Syl is the Old English word for "pillar" or "column." Faience refers to glazed, highly decorated earthenware.*

Cris uses patterns from the gothic architecture found in London to add movement and texture to millennia-old Stonehenge (above). Different tangleations of Syl and Faience mimic the shadows, highlights, and textures of the rock. The play of light and shadow create added interest.

Amp Up Your Work through Midtone Studies

This chapter focuses our journey on an exploration conducted on midtone papers in gray, which is a cool tone, and tan, a warm tone. Midtone paper requires the artist to create both the shadows and highlights on the objects and shapes drawn. As the sun moves throughout the day, lighting changes, causing a change in the intensity of the shadows and highlights that light creates on objects. Light cast at daybreak creates highlights and shadows that are close in range, whereas afternoon bright sunlight will have twice the tonal range between the highlights and shadows. Bringing the realistic characteristics of lighting into our art allows the artist to express time of day and create the environment, mood, dimension, volume, weight, and form with the tonal values of the highlights and shadows. Understanding the effects of lighting on tonal values is one of the fastest ways to improve our artwork.

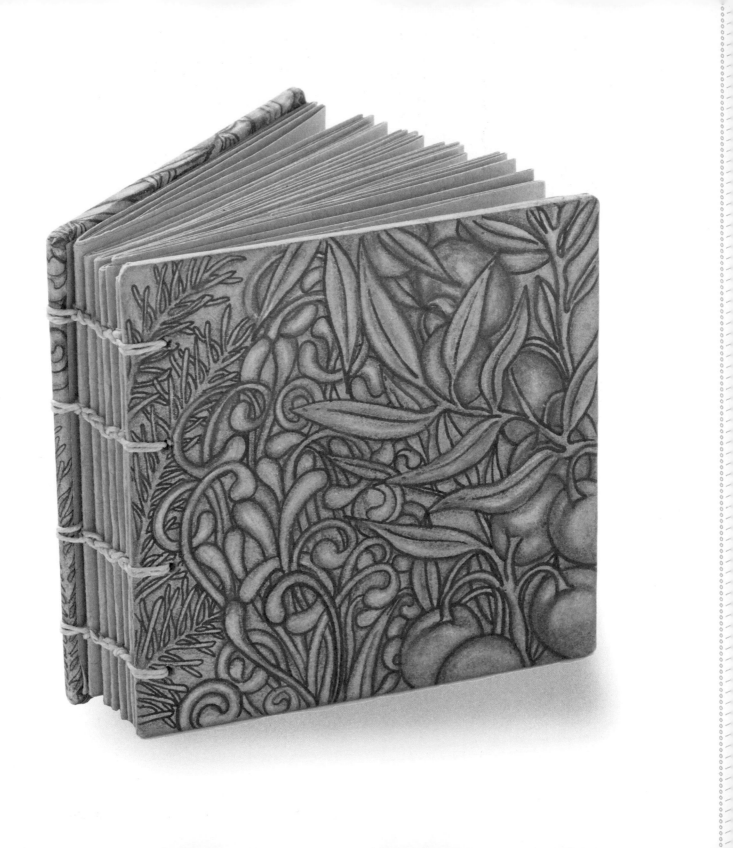

Midtone, Single-Stitch, Coptic-Bound Book

Midtone papers require that highlights and shadows be added. Working on tan and gray gives us both warm and cool midtones to study the effects of each of these additions.

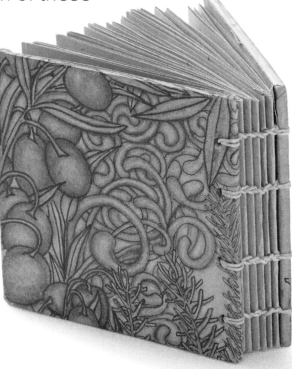

◄ **Front of book:** There is a gray cover on the front of this midtone sketchbook.

► **Back of book:** The back cover is tan and the signatures inside alternate gray and tan.

Materials

six midtone pages, three in tan and three in gray, cut or torn to 3½" x 7" (9 x 17.8 cm) each

six midtone pages, three in tan and three in gray, cut or torn to 3½" x 11" (9 x 28 cm) each

six midtone pages, three in tan and three in gray, cut or torn to 3½" x 14" (9 x 35.6 cm) each

pencil

ruler

bone folder or guitar pick

scrap paper, cut to 3½" x 2" wide (9 cm high x 5 cm wide) for binding-hole guide

self-healing cutting mat

box cutter

awl

two pieces of book board or four-ply chipboard, cut to 3½" x 3½" (9 x 9 cm) each

two pieces of midtone paper for the cover, one tan and one gray, cut to 4½" x 4½" (11.4 x 11.4 cm) each

two pieces of midtone paper for the inside cover page, one tan and one gray, cut to 3¼" x 3¼" (8.2 x 8.2 cm) each

⅛" (3 mm) screw punch or punch and hammer

red liner tape or white glue (I use US ArtQuest's PPA Matte)

curved needle or binding needle

binding thread

Instructions

A 3½" x 7" (9 x 17.8 cm)

B 3½" x 11" (9 x 28 cm)

C 3½" x 14" (9 x 35.6 cm)

▲ *Folded pages*

1. Place all the papers in landscape mode and fold them as described below. Press all the folds created on each page with a bone folder or guitar pick.

- Fold each of the 3½" x 7" (9 x 17.8 cm) papers in half crosswise; press and set aside **(A)**.

- Fold each of the 3½" x 11" (9 x 28 cm) papers in half crosswise; these are the signature wrappers **(B)**.

Open each and mark 2" (5 cm) from both outer edges, and then fold to the inside, creating two flaps. The fold-in flaps are for notes, listing the tangles and pens, or whatever you decide. Press and set aside **(B)**.

- The 3½" x 14" (9 x 35.6 cm) papers make a four-panel page. Fold each page in half crosswise; open and bring the left edge to the center fold line, press. Repeat for the right-hand side. Close each signature, press, and set aside **(C)**.

2. Collate the pages into three tan signatures and three gray signature, starting with the tan pages. Place a folded 3½" x 14" (9 x 35.6 cm) page within a folded 3½" x 7" (9 x 17.8 cm) page and cover with the 3½" x 11" (9 x 28 cm) piece to create signature wrapper. Lightly pencil a T on the front top-right corner. Create the rest of the tan and gray signatures in the same way (including penciling a T on each).

3. Create the binding hole guide by folding a 3½" x 2" (9 x 5 cm) piece of scrap paper in half lengthwise and again pencil a T in the top corner.

 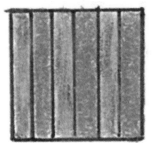

D

▲ Binding-hole guide and collated signatures

Create a binding hole guide (the white area on the open signature in the diagram above) using scrap paper as directed in step 3. Keep the crease of the binding-hole template in the crease on the signature to ensure the binding holes on each signature will line up.

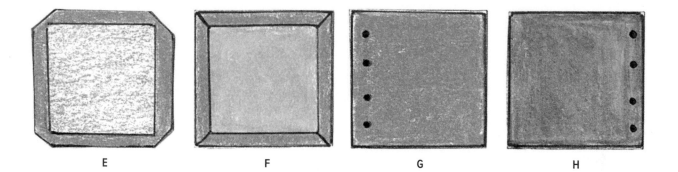

E F G H

▲ Making the covers

I chose the gray paper to create the front cover and the tan for the back cover.

4. Measure and make a dot on the fold ½", 1¼", 2¼", and 3" (1.3, 3.2, 5.8, and 7.6 cm) from the top. One at a time, place each signature on the cutting mat and open it to the center. Center the fold of the binding-hole guide over the center fold of the open signature and use the awl to punch the four binding holes into the signature. Refold and set aside. When all six signatures are punched, collate the signatures in order, alternating colors, with the spines on the left **(D)**.

5. Affix a book board onto each center of the 4½" x 4½" (11.4 x 11.4 cm) gray and tan papers. Cut the four corners off of each, leaving enough paper to cover the corner of the book boards **(E)**.

6. Fold the edges of paper up onto the book board, and fix them in place. Center and adhere the 3½" x 3½" (9 x 9 cm) tan paper to the gray covered book. Center and adhere the 3½" x 3½" (9 x 9 cm) gray paper to the center of the tan covered book **(F)**.

7. Decide which cover will be the front cover and which will be the back. Place the covers, front sides up, on the cutting mat. Place the binding-hole guide ¼" (6 mm) in from the left side of the front cover. Mark the holes with a pencil. Use the ⅛" (3 mm) side of the screw punch to punch the four holes **(G)**.

8. Place the binding-hole guide ¼" (6 mm) in from the right side of the back cover. Mark the holes with a pencil. Use the ⅛" (3 mm) side of the screw punch to punch the four holes **(H)**.

9. Correlate the covers and signatures and place the book with the back cover facing you. Follow the directions for the coptic binding on page 136 to sew the book together.

Drawing on the Midtone Side

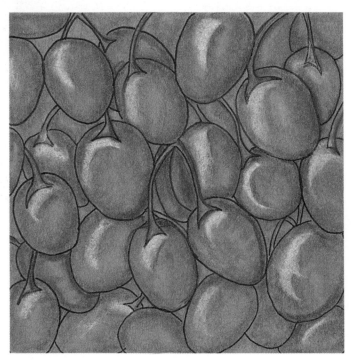

▲ *Daily meditative tile on midtone paper*

Although tangles are abstract, they still require tonal shading to detail shapes, atmosphere, and a sense of logic in a completed tile.

Materials

black marker

piece of 3" x 9" (7.6 x 23 cm) white drawing paper

ruler

2B pencil

white chalk pencil

Prismacolor colored pencils: white #930, 10% cool gray #1059,
20% cool gray #1060, 30% cool gray #1061, 50% cool gray #1063,
70% cool gray #1065, 90% cool gray #1067, black #935

scissors or cutting tool

¼" (6 mm) hole punch

midtone, single-stitch, coptic-bound sketchbook (page 69)

01 drawing pen

▲ *Black ink drawing on gray paper*

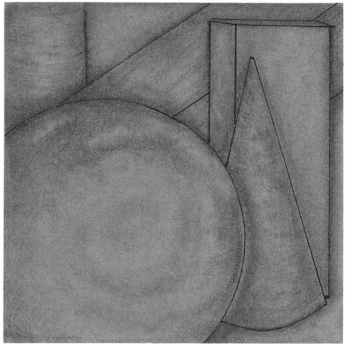

▲ *Black and gray drawing on gray paper*

Highlights, shadows, and darks can express a mood or time of day and enable the viewer to grasp the shape of a form and infer a sense of volume, weight, and solidity. To ensure our success in this lesson, we are going to create a value scale known as a *gray scale*.

The addition of gray in the second image (top, right) adds dimension and mood to this drawing. The third picture (left) adds highlights (with white), providing greater depth and lighting. This also suggests it was drawn when the sun was just coming up.

Using a circle, square, rectangle, cone, and column shape, create a design on the first gray and tan pages in your sketchbook. This will be your value study for the next four lessons practicing the use of tonal values.

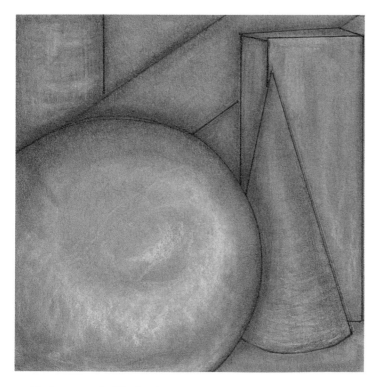

▲ *Black, gray, and white drawing on gray paper*

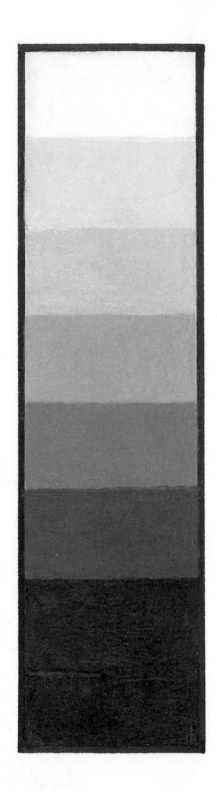

◄ *Creating a gray scale*

Instructions

1. Using a bold marker, draw a 2" x 8" (5 x 20.3 cm) rectangle in the center of the white drawing paper. The first (top) section is white. Starting at the top, measure 1" (2.5 cm) down and, using the white colored pencil, draw a line across from side to side.

2. Color only the top 1" (2.5 cm) of the scale in white. When using colored pencils, use three light layers applied in three different directions to achieve complete coverage. Color the first layer with light pressure in a horizontal direction from right to left. Then color over that layer in a diagonal direction. Lastly, color in a vertical direction.

3. Measure 1" (2.5 cm) from the bottom of the white section and mark this section by coloring it in with the 10% cool gray pencil.

4. Repeat steps 2 and 3 using the 20%, 30%, 50%, 70%, and 90% cool grays, and lastly, the black.

5. Cut the gray scale in half vertically. Using a ¼" (6 mm) punch, make a hole in the top left corner of each color on the left side.

6. Use the half with the peep holes to practice identifying tonal values. Start with a magazine picture. Let your eyes soften and go out of focus as you try to match the value of the shadows in the picture to the closest value on your chart. When they match up, you will see the value on the chart and the value of the picture fall or blend together.

▶ *Right side of gray scale*

◀ *Left side of gray scale*

The "peep" holes on the left-hand scale are helpful when trying to identify a tonal value by isolating the area and surrounding it with each value option.

Overcast Values

The amount of light an object is situated in creates tonal values, which help us establish the atmosphere and mood, imply the time of day when the piece was drawn, produce dimension, and add interest—all factors that help draw in the viewer.

Materials

gray scale (page 74)

2B pencil

Stabilo white Aquarellable or white Caran d'Arche pencil

01 drawing pen

midtone, single-stitch, coptic-bound sketchbook (page 69)

white glove or absorbent towel

tortillon

▲ Gray scale with right side slid up one range

Working on midtones allows the artist to manipulate both highlights and shadows, creating mood and atmosphere. The next four lessons (2 through 5) are value studies. Each uses different lighting for visual effect, some focusing on gradation of highlighted areas, others on shadows to create mood.

Splitting the gray scale in half enables one side to slide up or down to determine the correct tonal range between the shadows and highlights of each lighting style. This tool also helps select the atmosphere and mood setting for the drawing. Align both gray-scale halves with white at the top.

The white on the left side will be used for the highlights in this lesson. Slide the right side up one square—or as referred to in art terms, *one range*—so that the lightest gray on the right is now aligned with the white on the left. The 10% cool gray will be the tone used for shadows.

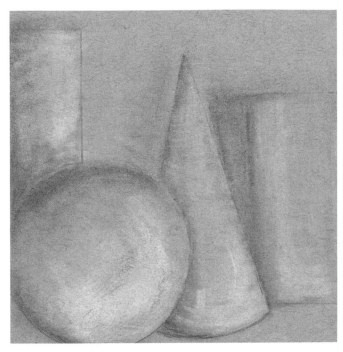

▲ *Create a template in your sketchbook composed of a circle, cone, rectangle, and square on page one of the first tan signature.*

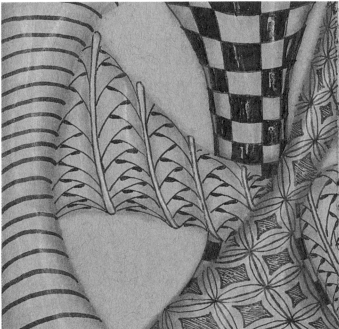

▲ *Here the light undershading adds dimension to the highlighted areas. The light is overcast, coming from the right, slightly overhead. The light shines vertically, producing smaller shadows under the objects. Overcast conditions create minimal highlights and shadows.*

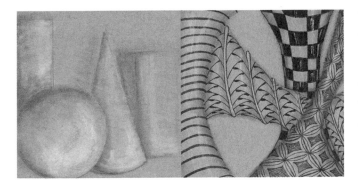

▲ **First tan paper tile of four-panel value**
When viewed with unfocused eyes, the two pictures blend together because of their common tonal values.

This combination of high-key (which refers to highlights) and low-key (or the shadows) tones appears on overcast days and at daybreak.

To start our lighting values study, turn to the center four-panel spread in the first tan signature and repeat the design you created on page 75 in the first panel. Also, repeat the design in the gray signature's first panel. Practice creating overcast values on both pages.

Turn to a clean sheet in your sketchbook and create a ZIA drawing using overcast values for the highlights and shadows. When working on midtone paper, place an absorbent towel under your hand to keep the oils from your hands getting on the paper and to prevent smudging your highlights and shading.

Midmorning or Afternoon Values

This lesson focuses on the values found on a bright sunny day. Bright natural light's highlights and shadows are found in a range of three: Start with the whites lined up on the grayscale; the highlight will be the white. Move the right scale up three ranges; that means 30% cool gray is the tone for the shadows.

Materials

gray scale (page 74)

2B pencil

white Stabilo Aquarellable or white Caran d'Arche pencil

01 drawing pen

single-stitch midtone coptic-bound sketchbook (page 69)

◀ **Gray scale with the right side moved up three ranges** *The 30% cool gray will be your darkest tone.*

Draw the template created for the value study (page 75) in the second panel on your tan and gray signatures.

The lateral light hits the objects from the side, slightly elevated. Lateral lighting produces strong contrasts between highlights and shadows. The highlights on the example remain on the left side where the light is coming from and have intensity; the shadows fall behind. The darkest shadows are on the backs of the objects; the shadows lighten as they fade away from the object.

Turn to a blank page in your sketchbook and create a drawing that uses lateral lighting to create the highlights and shadows.

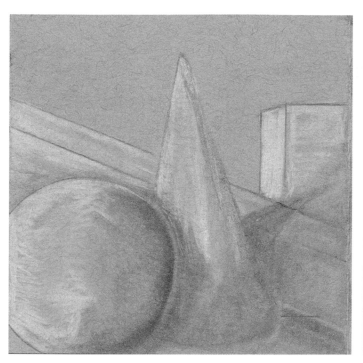

▲ *Second panel on the tan value study*

▲ **Tan midtone 4" x 4" (10.2 x 10.2 cm) piece with the tangle Immortality**
The tonal values were chosen using the gray scale. The gray scale provides correct corresponding values of highlights and shadows.

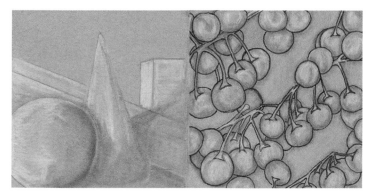

◄ *View the tonal study with the meditative tile with unfocused eyes. The meditative tile is much busier than the value study, but the common tonal values allow them to blend together.*

Lightbulb Values

With two of the four panels finished, you can see the diversity that comes when light sources or direction is changed. Draw the objects used on the previous panels for the value study in the third panel on your tan and gray signatures.

Materials

gray scale (page 74)

2B pencil

white Stabilo Aquarellable or white Caran d'Arche pencil

01 drawing pen (I used Zig Drawing Pen or Marvy LePen Technical Drawing Pen)

midtone single-stitch coptic-bound sketchbook (page 69)

◄ Value study with the right side moved up four ranges

The third panel in the value study is lit by frontal light from a bare lightbulb, which is a range of four shades. Slide the right side up four ranges so that the lightest gray is now aligned with the white on the right side. The 50% cool gray will be the darkest tone of the shadows.

Frontal light reaches the objects from the position of the viewer. The foreground is lighter and the high-key areas are predominant in this lighting because the shadows fall behind the subjects and fade away into the distance. This lighting style creates an atmosphere that feels lighter and brighter.

Draw the template created for your value study in the third panel of the tan and gray four-panel pages. Practice shading and highlighting with lightbulb values.

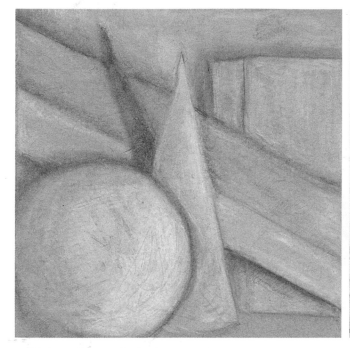

▲ **Third panel of tan value study**
I chose 20% cool gray for midtones because frontal light is bright. Notice that the shadow area does have a dark area of 50% cool gray that quickly lightens as it graduates off into the background.

▲ **Meditative tile on tan paper with the tangle Expanding**
Create depth by gradating the highlights so they are darker in the center and lighter on the edges, then add your gradated shadows.

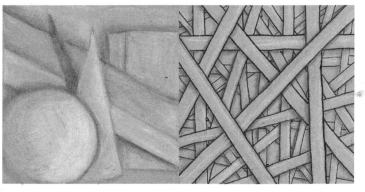

Turn to a blank page in your sketchbook and create a ZIA drawing that uses lightbulb values in the highlights and shadows.

◀ *This lighting style gives the artist an opportunity to expand techniques for graduating tones in the highlights.*

Twilight Values

Twilight lighting can be used to create a mysterious atmosphere. The larger tonal range in this lighting focuses in the shadows. Often called *conte-jour*, French for "against the daylight," this lighting hides details and instead concentrates on shapes and line.

Materials

gray scale (page 74)

2B pencil

white Stabilo Aquarellable pencil or white Caran d'Arche pencil

01 drawing pen (I used Marvy LePen Technical Drawing Pen or Zig Drawing Pen)

midtone single-stitch coptic-bound sketchbook (page 69)

The contrast between the subject and backlighting pulls the viewer into the subject. In the fourth panel of our value study, the lighting moves to backlighting. Twilight lighting comes from behind an object, placing it in the shadows. The foreground is represented in darkened shadows that are stronger than the background. The background is lustrous with glowing highlights. Draw the objects used on the previous panels for the value study in the last panel of your tan and gray signatures.

Twilight lighting comes from behind, and again we will be working in a range of five. Unlike nature, which falls in an eight-to-one range, artists always have to limit the number of tonal values they use in a piece. This is especially important when creating small works.

◄ Gray scale with the right side moved up five ranges

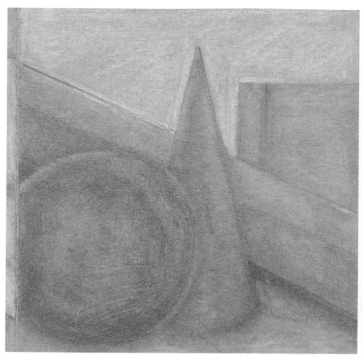

▲ **Fourth panel of tan value study**
I chose white and 20% cool gray for midtones in the backlighting where the light is bright. I used 50% cool gray for the darkest shadows in the foreground midtones. The farther back in the piece the image appears, the lighter its tonal values are.

▲ *Tan sketchbook page with tangle Scholar is also an exception to the rule because this piece was facing west so the setting light hit on the front.*

In twilight lighting, the light comes from behind, and, normally, the forefront of the piece has no highlights. But as with everything, there are exceptions to the rule. This piece is in twilight shading, but there are reflective highlights cast to the forefront tangles by a side wall. Plein air drawing is essential for teaching us the rules and exceptions to lighting, shadows, and highlights.

Drama in the Silhouette

▲ Meditative tile in silhouette style

Silhouettes have been found in art as far back as cave drawings but were made popular in the 1700s. Associated with paper-cut portraits, the word silhouette *means to be completely lit from behind, a mood-invoking style used by artists and photographers frequently.*

Silhouette lighting has the largest tonal contrast and range found in nature, as high as eighteen to one. Silhouettes are backlit with a strong direct light, with no reflective or natural light from the front, causing the shapes in front of the light to appear black against a high-key, white background.

Traditionally, silhouettes were either painted, drawn with ink, or cut from paper. Painted silhouettes were done throughout history on plaster, card stock, paper, and reverse glass.

Create a couple of ZIA tiles in the silhouette style. Start with a pencil sketch or just draw the outline of the patterns onto your tile. Once the design is down, fill in with a drawing pen for even coverage. If the first tile is organic in nature, switch it up for the second and create an abstract or geometric tile.

Materials

2B pencil

01, 03, and 08 drawing pens

white tiles

one piece of 4" x 4" (10.2 x 10.2 cm) white drawing paper

one piece of 4" x 5" (10.2 x 12.7 cm) white drawing paper

midtone single-stitch coptic-bound sketchbook (page 69)

◀ *Silhouette of curly lines and spiked blobs*

▲ **Silhouette of objects from the Lesson 5 study**
Shapes were rearranged to take advantage of the lighting. The square became the light source; the other shapes were arranged within it.

▲ *Silhouettes are perfect for emulating new subjects or patterns. Create a small 4" x 5" (10.2 x 12.7 cm) art work in silhouette style. Start this piece with an emulated subject, like the songbirds in the piece above, and then fill in the rest of it with patterns of your choice.*

▲ **Silhouette in white with black background**
Drawn silhouettes allow the artist to bring a drawing to life in a negative world. The first abstract piece takes advantage of thin, active lines to add energy and large darkened shapes to ground them. The second, with the white focal pieces in white paint on a black background, is also a correct form of silhouette art.

Tonal Values and Color

Every tonal value lesson we learned in this chapter remains the same when we are working in a color palette. Colored midtones make perfect backdrops for a drawing. They can help establish mood or create an atmospheric setting for your drawing.

Materials

For the colored midtone paper sketchbooks
three pieces of white drawing paper cut to each size (nine pieces total): 3½" x 7" (9 x 17.8 cm), 3½" x 11" (9 x 28 cm), and 3½" x 14" (9 x 35.6 cm), folded and collated to create three signatures like the ones created for this chapter's sketchbook (page 69)

pastel or chalk in the midtone color of your choice

working fixative

For the midtone artist trading card (ATC)
old book page, cut to 2½" x 3½" (6.4 x 9 cm)

gouache in three midtone color shades

gel pens

paintbrush

distilled water for thinning paint and rinsing brush

Abstract studies (opposite) on tan and gray papers. The tan piece's tonal values are reflective of early daybreak light. The gray piece is highlighted and shaded with afternoon or bright light.

▲ *Tan two-page spread*

▲ *Gray two-page spread*

▲ *Gray single-panel morning piece*

▲ *Tan single-panel column piece*

Subjects for our drawings change, but tonal patterns always work the same, no matter what we draw.

To create a small colored midtone sketchbook (shown below), start by covering your work surface to protect it and lay out the white pages cut to size for signatures. Use the pastel or chalk to color the front and back of each page; tap the pages edge against your work surface to remove any excess dust from the pages. Finish by lightly wiping the surface of the paper to remove any excess chalk or pastel. You cannot erase the color from the paper to create lighter highlights if you spray the pages with fixative before drawing on them. Fold and bind your pages as described on page 69.

◄ **Yellow midtone paper**
This sketchbook was colored with chalk. The drawing is created with ink, colored pencil, and an eraser to lighten highlighted areas.

◄ **Purple midtone sketchbook**

▶ **Green midtone sketchbook**

These sketchbooks were created like the signatures in this chapter's sketchbook (page 69) and sewn together with the pamphlet stitch (page 135). The paper for this purple sketchbook was created with chalk; the green used PanPastel.

Divide the artist trading card (ATC) into sections. Using three different colors of gouache, paint in the shapes and let them dry. When dry, use gel pens to tangle the sections of the ATC.

▶ **ATC color-toned collage**
Fun and quick to make, this ATC is ready for trading.

Tangled Artworks

Our journey takes us onward to focus on expanding your personal tangle journey and pulling together the knowledge and experience you have acquired along the way. We are learning to draw with metal points such as the great art masters. Metal-point work has a unique look unlike any other medium that draws the viewer in and holds their attention. This work must be seen in person to do it justice. From classical art we move to modern art movements that work wonderfully with tangled and emulated art. Ideas and projects are covered for working art into your daily life, tangles into your art pieces, as well as projects for adorning you and your home, using some of your already-completed tiles and drawing. Finally, to lead you out to further your art journey, we will look at participating in art swaps and exhibits.

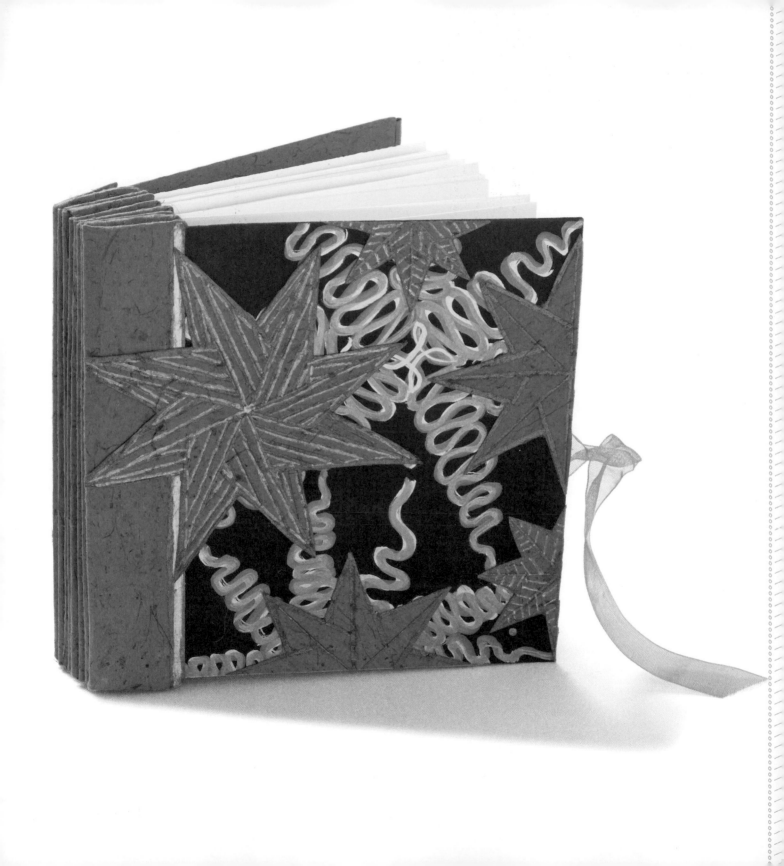

A Crown Book Portfolio

This chapter focuses on using all we have learned in our sketchbook studies to create several art pieces, so we will make a Crown Book Portfolio to keep them in. The crown binding was created by Hedi Kyle; it is a slighty altered version of her Blizzard Book.

Materials

one piece of Lotka paper, cut to 7⅜" x 18" (18.7 x 45.7 cm) to hold 5" x 5" (12.7 x 12.7 cm) paper, or cut to 9½" x 28" (24.1 x 71.1 cm) to hold 6" x 6" (15.2 x 15.2 cm) paper

bone folder

one piece of illustration board, cut to 5⅛" x 5⅛" (13 x 13 cm) for a 5" (12.7 cm) book, or cut to 6⅛" x 6⅛" (15.6 x 15.6 cm) for 6" (15.2 cm) book

two pieces of decorative paper for inside cover sheets, cut to 5" x 5" (12.7 x 12.7 cm) for a 5" (12.7 cm) book, or cut to 6" x 6" (15.2 x 15.2 cm) for a 6" (15.2 cm) book

two 6" (15.2 cm) lengths of ribbon, ¼" (6 mm) or ½" (1.3 cm) wide (optional)

glue or red liner tape (optional)

two pieces of paper for covering illustration board exterior, cut to 6" x 6" (15.2 x 15.2 cm) for 5" (12.7 cm) book, or cut to 7" x 7" (17.8 x 17.8 cm) for 6" (15.2 cm) book

The Crown Book Portfolio starts as an accordion or fan-fold book.

Instructions

1. Place your paper in landscape mode **(A)**.

A

2. Fold the paper in half crosswise and press the fold with a bone folder **(B)**.

B

C

3. Fold the paper in half crosswise once more and press the fold with a bone folder. The paper is now folded into four quarters **(C)**.

4. Open the paper up and lay it in landscape mode **(D)**.

5. Starting on the left side, bring the first fold to the edge of the paper and crease the fold with the bone folder.

6. Repeat step 5 for the remaining folds. This will divide the paper into eighths **(E)**.

7. Repeats steps 5 and 6. This will divide the paper into sixteenths **(F)**.

8. Place the folded paper so that the first page opens like a book, or in other words, beginning with a valley fold **(G)**.

9. Open the first page and fold in the top and bottom corners over to the center spine. Fold the top and bottom corners of the right page to the center spine. Fold in the top and bottom corners on the rest of the pages. Burnish all the folds on the corners **(H)**.

D

◀ *Reopen the paper in landscape mode and start from the left. As in steps 4 and 5, bring the seven folds and the right-hand edge to the left edge and press each fold.*

E

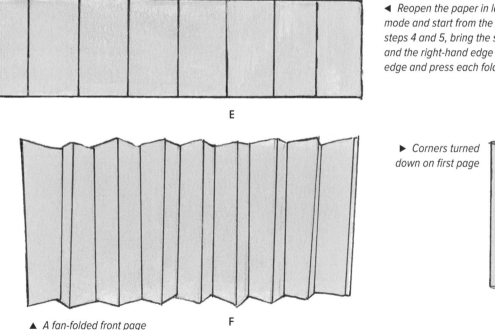

▲ *A fan-folded front page* F

▶ *Corners turned down on first page*

G

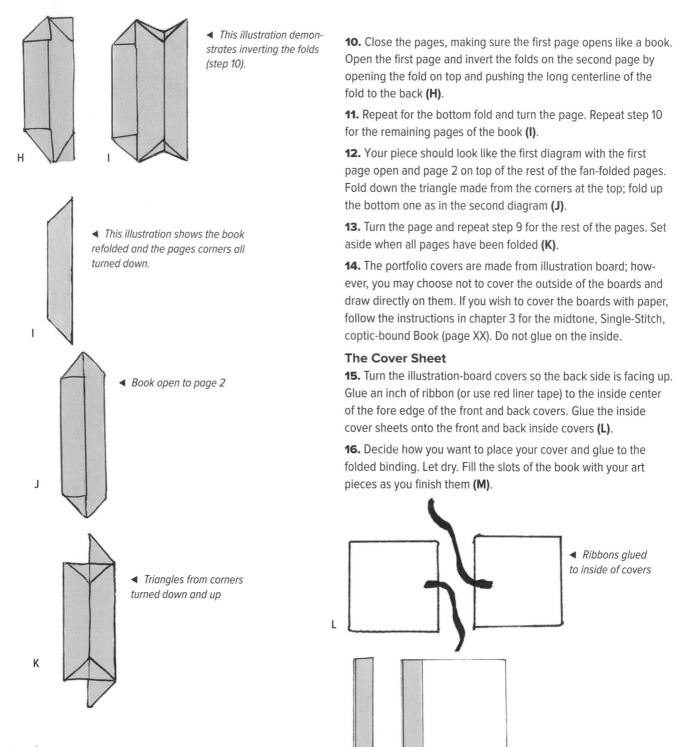

◄ This illustration demonstrates inverting the folds (step 10).

10. Close the pages, making sure the first page opens like a book. Open the first page and invert the folds on the second page by opening the fold on top and pushing the long centerline of the fold to the back **(H)**.

11. Repeat for the bottom fold and turn the page. Repeat step 10 for the remaining pages of the book **(I)**.

12. Your piece should look like the first diagram with the first page open and page 2 on top of the rest of the fan-folded pages. Fold down the triangle made from the corners at the top; fold up the bottom one as in the second diagram **(J)**.

13. Turn the page and repeat step 9 for the rest of the pages. Set aside when all pages have been folded **(K)**.

14. The portfolio covers are made from illustration board; however, you may choose not to cover the outside of the boards and draw directly on them. If you wish to cover the boards with paper, follow the instructions in chapter 3 for the midtone, Single-Stitch, coptic-bound Book (page XX). Do not glue on the inside.

The Cover Sheet

15. Turn the illustration-board covers so the back side is facing up. Glue an inch of ribbon (or use red liner tape) to the inside center of the fore edge of the front and back covers. Glue the inside cover sheets onto the front and back inside covers **(L)**.

16. Decide how you want to place your cover and glue to the folded binding. Let dry. Fill the slots of the book with your art pieces as you finish them **(M)**.

H

I

◄ This illustration shows the book refolded and the pages corners all turned down.

I

◄ Book open to page 2

J

◄ Triangles from corners turned down and up

K

L

◄ Ribbons glued to inside of covers

M

▲ **Finished sample book**
The covers can be attached two ways. This book has the covers glued onto the outside of the first page and the last page of the folded-book block.

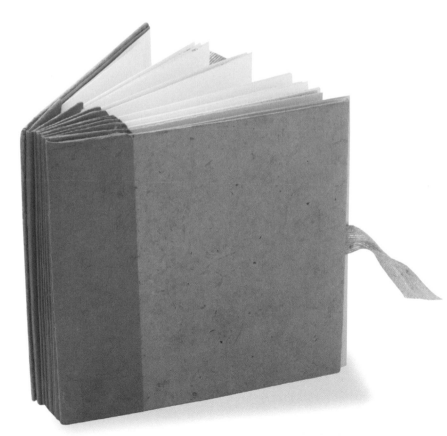

◄ *This book has the covers glued into the first and last pages of the book block.*

Silhouettes: The Timeless Selfie

▲ **Meditative tile using the tangle D**
The tangle D lets us focus on the pen strokes from the beginning to the end; it was the focus of this meditative tile. In it, every straight line is followed by a curved line.

The focus of this lesson is to create a silhouette self-portrait. Painted portraits in silhouette have been popular since the early 1700s. Silhouettes naturally occur when the subject is in front of a strong light source without any other light source falling on the subject. This causes the subject outline and form to appear as a solid single-colored dark shape with a featureless interior. If background features are included, they appear in the light.

Materials

005, 01, 03, and 08 drawing pens (I used Zig pens and Marvy LePen Technical Drawing Pens)

gray marker (I used a Tombow Dual Brush water-based marker)

several pieces of drawing paper, cut to 4" x 6" (10.2 x 15.2 cm)

crown book portfolio (page 95) for holding the finished artwork

camera and printer for creating a selfie

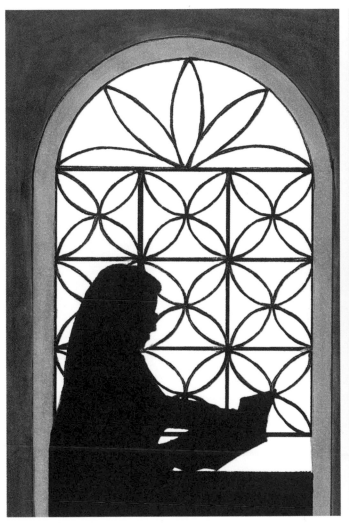

▲ Silhouettes were popularized as a cheaper alternative to the miniature portrait. This pen-and-ink drawing of me is rendered in the classical silhouette style and drawn on a white background. The tangle D was used to create a window.

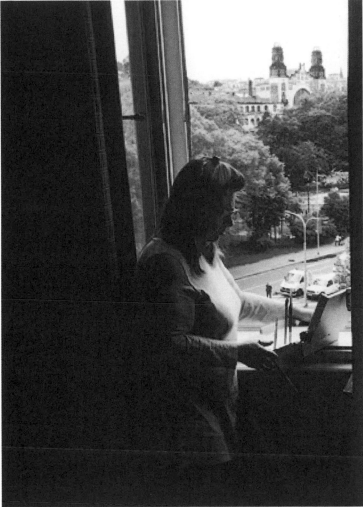

▲ Cameras brought a new emphasis to the silhouette in the nineteenth century. Popular with photographers, this cheaper form of producing a silhouetted portrait included lit backgrounds with features that were illuminated. The objects and shapes in the background light are recognizable and fully visible.

▲ *Ink silhouette drawing with illuminated park background*

A successful silhouette depends on a strong outline of the subject that is filled in solidly in dark colors. The human silhouette breaks down into curved, angled, and straight lines—they are no different than the strokes we use to create tangles. Use a picture or mirror to emulate your outline. Fill in your image with a single solid dark color. Create a window or opening for your light source. Decide whether you are doing a classical or abstract background, and treat the background appropriately.

◄ The first silhouette uses the tangle D to create the window. I love creating mixed-media pieces in ink combined with colored pencils in the silhouette style. The inked silhouette anchors the piece, while the colored pencil backgrounds give an ethereal feel to the background.

◄ Ink was used to draw my silhouette and the darkened areas of the room and the park outside. Then gouache and colored pencils were used to color in the outside.

Visual Journaling: Life's Stories

▲ Sample blank calendar page

I transfer my calendar from my computer onto a paper calendar weekly. The template above is printed onto hot-press watercolor paper, folded, and collated into a signature. The date and my schedule are filled in with a pigment or permanent pen because I collage or transfer pictures of the day's events using matte medium and do not want the ink to run.

Visual journaling is a natural progression in a tangling journey; I practice it daily in many aspects of my lifestyle, but I'm most consistent in my calendar. It allows me to express my thoughts in a personal way, experiment with ideas as they occur, and record both my individual and art journey.

Materials

inkjet or laser copies of snapshots

1" (2.5 cm) brush and a few detail brushes

matte medium

two pieces of 8" x 16" (20.3 x 40.6 cm) watercolor paper, each folded in half to create an 8" x 8" (20.3 x 20.3 cm) booklet with four pages

bone folder or old credit card

pigment sticks or gouache (I used Faber-Castell Gelatos pigment sticks)

drawing pen (I used Marvy LePen Technical Drawing Pens or Zig pens)

crown book portfolio (page 95) for holding the finished artwork

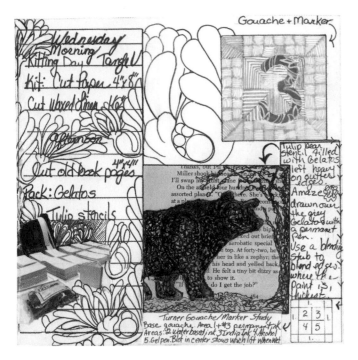

▲ Sample calendar page from a studio day

My paper calendar archives and details the aspects of my journey because it is always nearby as I work. Information on lifestyle, art, tasks, ideas, inspiration, and experiences fill the pages.

▲ Sample calendar page from a travel day

Our smartphones always ensure a camera is at hand, enabling us to capture inspiration on the fly. A hotel business center or a copy center makes it easy to print pictures and place them in my calendar or sketchbook while the inspiration is fresh.

In the example of a typical studio day (above, left), the area around the numeral 3 in the date box is painted with an acrylic gouache to test its compatibility with various markers. A new addition to our aquarium—a decorative clam—inspired a tangle, so I drew a large version on the page between the task list and date. When the task list was complete, I snapped a picture with my phone and printed it. I collaged it onto the calendar page by tearing it out, brushing matte medium on the back, and adhering it in place at the bottom of the list. To get back into the zone after lunch, I added the new tangle around the collaged picture and task list. Next, a few new techniques were used to create a sample for an upcoming class on a page from an old book, and a duplicate was placed onto the page with matte medium. Step-out notes were written in boxes drawn to the right of the piece. Lastly, markers were tested on the gouache, and a key was created at the bottom of the page for documentation.

The calendar page (above, right) is from a trip to Washington, D.C. The photos were transferred onto the page with matte medium. The Capitol building is an inkjet print, which does not print as clearly or intensely as a laser print. The rest of the transfers are laser prints.

Here's how to make your own visual journal page with tangled images:

1. Copy a few photos on an inkjet or laser copy machine and tear out sections to transfer onto your journal page.

2. Brush a coat of matte medium over the surface of the journal page. Apply a coat of medium on the front of the photos to be transferred and place them face down on the page. Burnish with a bone folder or an old credit card to ensure contact, and set aside to dry.

3. When dry, carefully wet the back of the transferred photos with water and roll the paper away, leaving the image on the watercolor paper. Let dry. If lint from the paper you removed remains on the picture when it is dry, wet your fingers and use them to roll off the lint.

4. The piece now is ready to be drawn, painted, or printed on.

▲ **Card with rubbing**
Cards and stationery can be created quickly with images from tiles turned into Rub-Onz.

▲ **Floral rubbing gift card**

▲ **Feather rubbing**
Feather Rub-Onz work great in collages and journaling pages.

Drawings we create on meditative tiles and sketchbook pages can be used to adorn our lives. Favorite drawings can be scanned and printed onto cards and journal pages or to embellish household items using a Grafix Rub-Onz transfer film. Follow the manufacturer's instructions to create rubbings of your work.

▲ Fabric with a blue solar dye print

▲ Negative for the printed fabric
Using Photoshop or Lumi's solar app, drawings can be turned into negatives and then printed onto fabric with solar dyes.

▲ Magenta underdyed test strip
Experiment with test strips and get to know the dye you are using. This piece was taken out of the sun earlier than recommended and washed to stop it from developing darker so it could be used as a background print. Fabric markers were used to draw over it.

▼ Art bag with solar print in red
The graphics from a meditative tile were mirrored and placed together in Photoshop, then turned into a negative that was printed onto the film used for solar dyeing. I liked the look from the underdyed experiment above, so I used the technique on this art bag.

▲ Negative and mirror-image negative for art bag

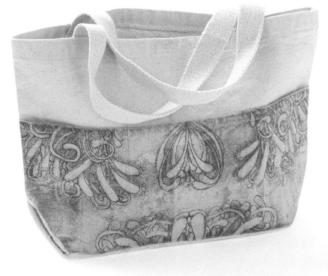

Solar dyes make it easy to transform fabrics quickly and easily. They allow us to permanently solar print our drawing directly onto fabric. Fabric, clothing, or premade items can all be transformed with our drawings. Follow the manufacturer's directions on the solar dye for a quick and easy project that does not change the hand of the fabric.

Share and Learn

The best way to master anything is to first learn it, then practice it, and finally teach it. In this lesson I picked three friends who all create in art forms that I am not as familiar with as they are.

Materials

For the Bracelets

two sheets of decorative paper cut into seventy-three chain pieces measuring ¼" x 3½" (6 mm x 9 cm) and two end pieces measuring 1" x 1¾" (2.5 x 4.4 cm)

paper cutter

Velcro for closures, ⅜" x 1½" (1 x 3.8 cm)

hot glue gun and glue sticks

die cuts

Bic Mark-It metallic markers

drawing pen for tangling (optional)

¹⁄₁₆" (1.6 mm) eyelets and setter

For the Cards

watercolor paper cut to desired card size

die cuts

envelopes

watercolor ground in buff and white (I used Daniel Smith Watercolor Ground to create a surface like watercolor paper)

paintbrushes

pigment drawing pens

Gelatos pigment sticks

water-based ink pens

gouache

¹⁄₁₆" (1.6 mm) eyelets and setter (we used this for the octopus and elephant die cuts). optional: ¹⁄₁₆" (1.6 mm) brads can be used

assorted decorations and embellishments (rhinestones, ribbon, thread, glitter, etc.)

For the Felted Sketchbook

background from the die cut

foam base to felt on

wool roving in various colors

two pieces of blended wool or pure wool felt for the cover and interior, 4" x 9" (10.2 x 23 cm) each

felting needle

wool yarn used to create lines

bone folder

embroidery floss

embroidery needles

ribbon for tying the book closed

The basis of all three of our projects was die cuts by Eye Connect Crafts. Each session began with exchanging tangles and practicing them. Next we selected our die cuts, designed our project, and jumped in. My goal was to learn something new from their art skills and to share my love of tangling.

My first co-creator was Abi Hodsdon, a fearless eleven-year-old maker with a great bravado attitude that she brings to projects. In the end, a gum-wrapper bracelet with an adorned focal point—our die cuts—became the project.

Instructions

|||

1. Fold each piece of ¼" x 3½" (6 mm x 9 cm) chain paper in half crosswise, open it, and fold each end back to the center. Fold it in half with tails on the inside **(A)**.

2. Create the chain by placing the tail ends of one piece into the "slots" of a second piece, and then slide it up to the center folded seam. This step of the project is an old craft passed down from generation to generation in schoolyards across the United States, and there are many online tutorials for this **(B)**.

3. Place the next piece into the second piece's open end. Repeat steps 1 and 2 to create three chains, each twenty-three pieces long **(C)**.

4. Fold the two end pieces to measure ½" x 1¾" (1.3 x 4.4 cm). Lay the three chains in a row with their ends lined up. Starting with the left-hand side, place the end of each chain inside one end cap, spacing them evenly, and glue each of the three chains inside that end piece. Repeat with the remaining end piece and the right-hand side.

(continued)

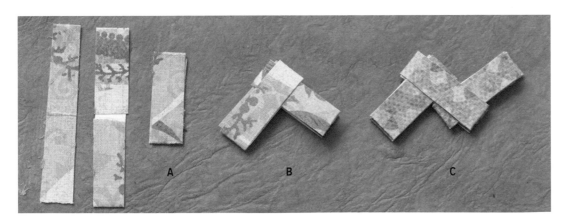

E *Four interwoven chain pieces*

5. Center and glue one side of Velcro to the top of the right-hand end piece and the other to the bottom of the left end piece **(D)**.

6. Connect four chain pieces into a square as shown **(E)**.

7. Glue the square onto the top center of the bracelet.

8. Color the die cuts. Abi colored hers all silver with a Bic metallic marker, then tangled with the blue. I colored mine with metallic markers and tangled it with a drawing pen.

9. Attach the die cut pieces together with eyelets and setter, following the manufacturer's instructions.

10. Attach the die cut onto the square on the bracelet with the glue gun. Gently shape the die cut into a curve that follows the form of the closed bracelet.

D *Finished gum wrapper chain bracelet*

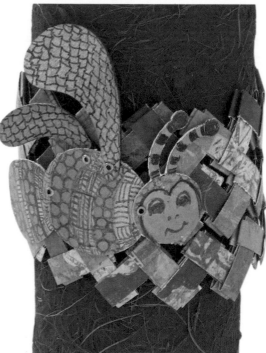

▲ **My bracelet**
To contrast with Abi's bright-colored dolphin, I chose colors that would give the bee a metallic look.

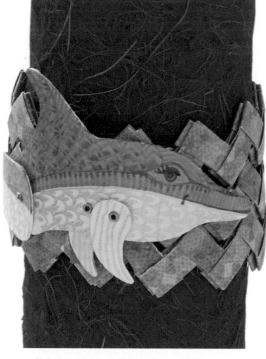

▲ *Abi's bracelet is stylish and eye-catching.*

My second co-creator was Liz Allen, an incredible card maker who loves to embellish. We decided to create cards with a gift. The die cuts can be removed from the card and hung.

◀ Liz's octopus card

Instructions

1. Select a card size that works best with your die cut.

2. Coat the die-cut pieces with watercolor ground, which gives a hot-press watercolor-paper texture to the die cuts. Let dry.

3. Liz first painted the card back and octopus with Gelatos. Metallic pens were used to tangle the octopus and draw his face. Eyelets were used to join his legs, and he was decorated with leftover embellishments Liz had.

(continued)

◄ **Liz's Marilyn Monroe card**

Liz began this elegant card painting the dress and gloves with watercolor ground. Dry tangles were drawn on the evening dress and card back, and then the quote was added. The card edge was deckled by tearing the paper before the dress and gloves were adhered to the card. Lastly, the dress and gloves were adorned with rhinestones.

▼ **My card**

I started my card by painting the elephant with watercolor ground, tangling the elephant with a pigment drawing pen, then coloring him in with water-based ink pens. I wrapped his tusks with rayon threads, then attached them with eyelets. The card's background was painted with gouache splatters.

The last co-creator was Michelle Muska, a talented fiber artist. We decided to do a felted needle book with embroidered embellishment to hold our needles.

Instructions

1. Butterflies are created by laying the stencil on the foam and filling the cutouts with roving. Jabbing the needle in and out felts the roving together, creating the felted butterfly wings and body. They were then removed from the foam and adhered to the cover by felting them together with the felting needle.

2. The tangles were drawn with wool yarn that was felted into place by repeatedly jabbing it with the needle. Roving was then felted with the needle to fill in the shapes.

3. Fold the felt page in half and run the bone folded over the fold several time to press the fold. Center the page on the inside of the cover. Use the felting needle on the pressed centerline from top to bottom through both the page and cover to felt the page into the spine.

4. Add embroidery to finish the embellishment on the cover.

5. Add the ribbon closures by felting or sewing them into place.

▲ **Foam, felting needle, and butterfly stencil**
We decided to use the cardboard the die cuts come out of as a stencil to felt our butterfly forms.

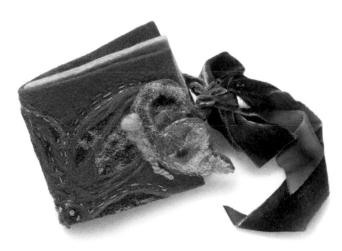

▲ **Michelle's felted book**
Michelle used more machine felting (using a felting machine) on her piece as background. She then used the embroidery to create texture and depth.

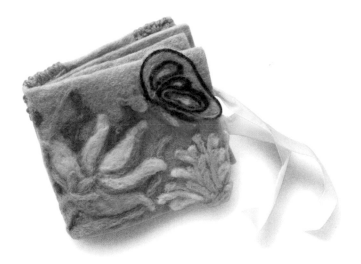

▲ **My felted book**
I needle sculpted the majority of my book cover; only the orange flowers were embroidered.

Metal Point: A Returning Classic

▲ *Piece done with silver, copper, and brass metal points*

Artists' drawing tools have changed drastically through time. In this lesson, drawing techniques are inspired by the great masters up to the mid 1500s. Metal point refers to drawings done using either silver, brass, or copper wire on a surface covered with a textured ground. Metal point—most commonly done in silverpoint—was the predecessor to the graphite pencil.

Materials

210 or 300 lb hot-press watercolor paper or Ampersand board 5" x 5" (12.7 x 12.7 cm) or less

traditional silverpoint ground (natural pigments), or prepared silverpoint ground by Golden

1" (2.5 cm) flat brush

fine-grit sandpaper

vinyl eraser

crown book portfolio (page 95) for holding the finished artwork

For a junk metal piece

metal items from around the house (nut picks, spoons, can opener, nail files, etc.)

For a metal point piece

2 mm and 0.9 mm metal styli to hold the drawing metals

Your choice of

• fine silver (99.9% pure silver) wire in 2 mm and 9 mm size

• copper wire in 2 mm and 9 mm size

• yellow or red brass points wire in 2 mm and 9 mm size

▲ **Silverpoint drawing on board**
Even when tarnished, the viewer can catch a sparkle of metal in the line of a fine silverpoint drawing on traditional ground. The soft tones and ethereal glow of silverpoint are impossible to replicate with other materials.

▲ **Silver and brass piece**
The foreground of this piece was drawn with fine silver and half-hard sterling silver. The background's line drawing is brass; brass, nickel, and silver are used in the triangle design.

Metal-point drawings have a softness that is very appealing. They never smudge, and the lines can be lightened with a vinyl eraser but never completely erased.

The ground comes two ways: Traditional silverpoint ground is a powder that you mix with water, or it can be purchased premixed. I use both and take advantage of their differences to enhance the mood of a drawing. I find traditional ground picks up more metal from the drawing tips.

The wire used to draw with is filed and then sanded to a rounded point on one end and a chiseled tip on the other. These prepared wires are called *points*. Metal points come in size 2 mm or 9 mm wire, which are placed in a drawing pencil stylus for use.

Silver wire comes in fine silver (the easiest to work with) and sterling. Sterling will oxidize faster. Both types turn brownish black when oxidized. Silver is available in three types: *dead soft* is the softest and leaves more metal behind, *half hard*, and *hardened*, which leaves the least amount of metal behind.

Brass comes in yellow, which oxidizes to a yellow brown, or red, which oxidizes into deeper orange tones that eventually become brown.

Copper, the softest metal, turns a greenish color. All metal points can be sharpened and shaped with sandpaper.

▲ Copper point piece

This was drawn in copper on paper prepared with traditional ground. When framing, metal-point pieces are not put under glass. This piece was created on Natural Pigment's metalpoint ground.

▲ The next two pieces where created on Golden's silverpoint ground. The piece above was used to test the point values of the metal points once tarnished. The aluminum point is the only one that does not change color over time. It is hardly noticeable in the photo. The piece to the right used junk metal to create it. A silver coin created the left tonal scale; the right used an old brass key. Other metal objects used were a nut pick, keys, an ice pick, coins, nails in copper, junk metal, a shower hook, and an old silver fork.

To prepare your drawing surface, cover paper or board with a coat of silverpoint ground, working vertically across the surface; let it dry. Apply a second coat, this time brushing the ground horizontally; let dry. Sand any imperfections away. Place a piece of paper between your hand and the surface of the ground to keep any oils off the surface.

Assorted metal pieces found around the house are used for the scrap and test piece for metal. Use a scrap of prepared paper to create a test piece. Note how they mark: Do they offer you control of the line you are making? What color do they oxidize, and so on? The mark left behind gives clues as to what metals they contain. Brass leaves yellow flakes in the line, copper releases reddish-brown flecks, and aluminum's line is a bright, light, non-tarnishing gray that is difficult to see in the pieces.

To determine the metals' colors when oxidized, place the test piece into a sealable plastic bag. To quicken oxidation, chop a hard-boiled egg into a small dish; place the egg in the dish carefully into the plastic bag with the metal piece you want to oxidize and seal it. Check it every six hours over a twenty-four-hour period. Pull the piece out when you're happy with the effect. Note the time it took to tarnish to the desired color on the back of the test strip and what was used.

Try creating several metal-point pieces. Experiment with different metals; they do not all feel the same to draw with.

◀ *This was drawn with metal points made of 0.999 silver, sterling silver, yellow brass, and copper on Golden's silverpoint ground.*

Participate and Exhibit

An artist's journey always expands when creating with others. It is easy enough to find artist calls for artwork in art magazines, at local art guilds and learning centers, and, of course, on the Internet.

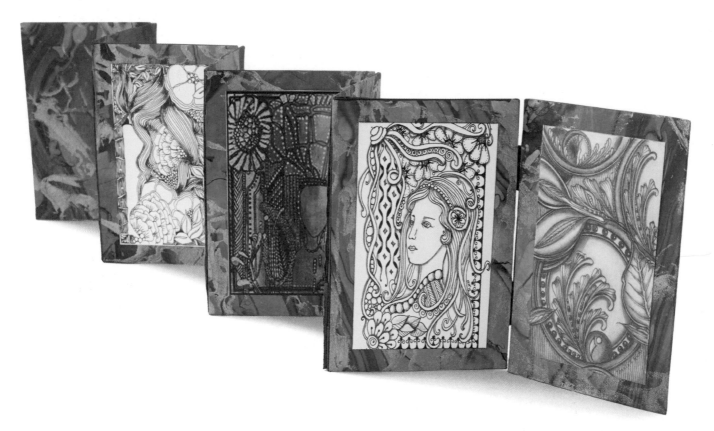

▲ **Inspired-by-Mucha swap book**
This swap's theme is inspirations from the work of Alfonse Mucha (1860–1939).
Mucha was a master at using repetitive patterns in his work.

There are artist trading card swaps, art book swaps, journal page swaps, the Sketchbook Project (sketchbookproject.com), and 365 Project (365project.org), just to name a few. If you have a group of friends who share your passion, organize a swap among yourselves.

The swap's guidelines stated the piece could be abstract or graphic, contain a figure or statue, or be completely organic. For our Mucha-inspired swap, each participant sent a 3" x 5" (7.6 x 12.7 cm) colored copy of their art piece for each participant in the swap to the swap coordinator. The pieces were collated and placed into a screen-hinged bound book, one for each participant.

If you are intimidated about drawing a figure, take a picture of your model. Cover the picture with tracing paper and trace their picture. Transfer the tracing onto your watercolor paper with graphite paper.

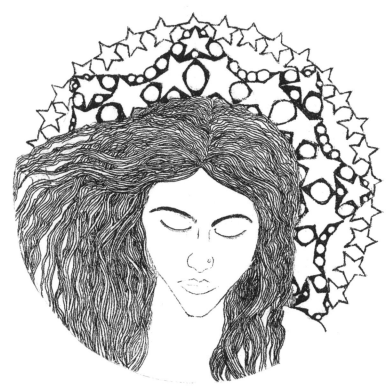

▲ Drawing of Jess on a Zendella

▶ Tracing paper crown options
Mucha used a round halo of graphics behind most of his female models, and I wanted to incorporate that aspect in my pieces, so I did this practice piece on a Zendella tile (which is a tangle drawn on a round tile versus a square one). To decide on the pattern to use for the haloed area, I covered the area with a piece of tracing paper and drew the various designs onto the tracing paper, which enabled me to see how they worked with the drawing underneath and to make a decision.

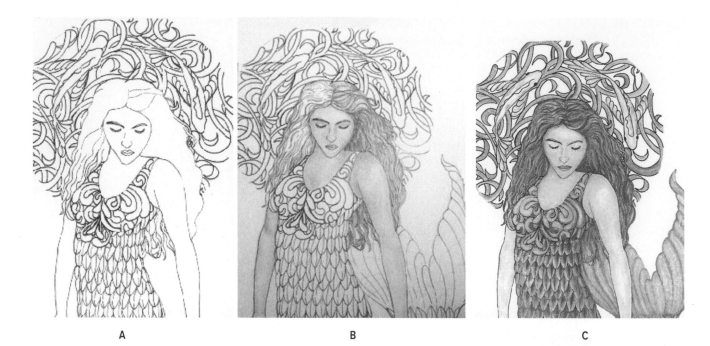

A

B

C

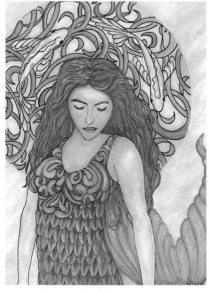

▶ *The progression of my piece: The drawing (A) was first colored in some areas with alcohol markers (B). Colored pencils were added in (C), and the marker background is included (D). The last picture, (E) shows the finished piece with the border done in colored pencils and markers.*

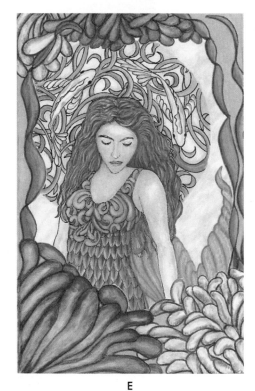

D

E

Tangle Journey

◄ Sharla Hicks created these three pieces and titled it The Circle Study. She says, "The use of circle-defined space and form has always inspired me and is a prevalent theme in Mucha's work."

▲ **Judy Lehman's piece**
Judy Lehman was inspired by the freedom of movement, repetition, organic beauty, and negative space that Mucha captured so beautifully.

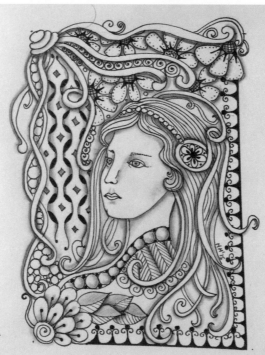

▲ **Sarah Hodsdon's piece**
Sarah Hodsdon was inspired by Mucha's use of environment to elevate the female subjects portrayed in his work and add to the story line of each piece.

◄ **Magdelena Muldoon's piece**
Magdalena Muldoon focused on the natural motifs, such as leafs, flowers, and swirls, to represent the essence of Art Nouveau's nature in this artwork.

Screen hinge binding is very simple and a great binding to hold a collection in since it stands open for display.

Materials

pages cut to desired size from illustration board or mat board (mine were 4" x 6" [10.2 x 15.2 cm])

printouts of the swap pieces cut to size (ours were 3" x 5" [7.5 x 12.7 cm])

decorative paper cut the same size as the mat board

Tyvek or ribbon for binding the book, cut into strips the desired width and 2" (5 cm) long (Note: You will need two pieces for every two pages bound together.)

glue (I use Perfect Paper Adhesive [PPA] by US ArtQuest)

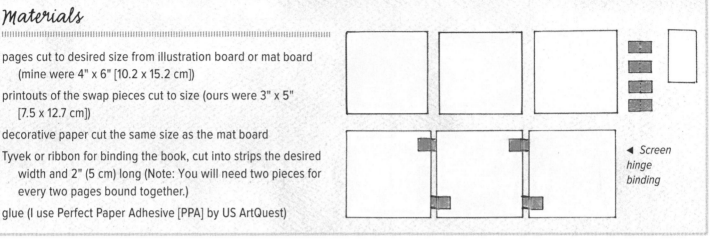

◄ Screen hinge binding

Instructions

1. Fold the binding strips in half crosswise.

2. Place the pages in order in front of you. Use a scrap piece of illustration board to measure a gap between the pages.

3. Following the diagram, glue half of a binding strip on the top, front, right-hand side of each page ½" (1.3 cm) down. Do not place one on the last page.

4. On the second and third pages, glue half of a binding strip to the bottom left-hand side the same distance from the bottom as you used in step 3 to affix the top hinge.

5. Glue the other half of each of the top hinge to the back of the page to its right.

6. Glue the other half of each bottom hinge to the back of the page to the hinge's left. Set aside to dry.

7. The book is now ready to adorn. The pages of the swap book pictured were covered in decorative paper on the front and back. The art pieces were then placed on the front of each page; the artist credits, a description of materials used, and artist statement were placed on the back.

◄ These art books are made from thin sheets of Mica to create pages that joined with a screen hinge binding.

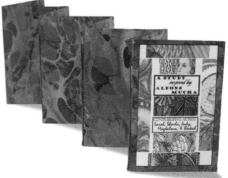

Edition-of-One Art Book: Unique Treasure

In the Introduction, I told you to save the strips from the paper we cut up to create our sketchbooks, and in this lesson we will use them.

Art books are a passion that I love making and sharing; usually they are one-of-a-kind pieces, but they can also be done in limited editions. Art books are mixed media by nature, because the artist creates the book, graphics, and print.

▲ **Blank art book**
This art book has an accordion book block with attached cover.

Materials

strip of leftover paper, 2" x 44" (5 x 111.8 cm) scraps of paper can be spliced together to create enough length

Rives BFK

ruler

bone folder

red liner tape

pens, markers, colored pencils—your choice of paper-compatible mediums

▶ *Scrap paper*

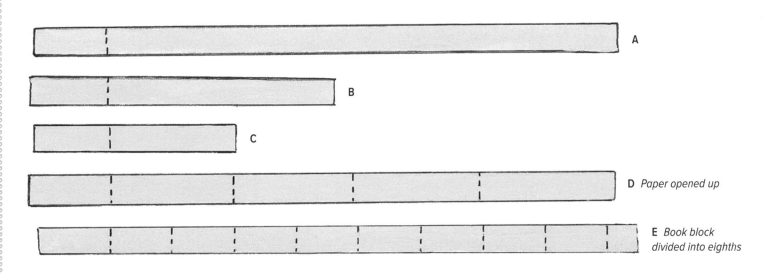

A

B

C

D *Paper opened up*

E *Book block divided into eighths*

Instructions

1. Measure 6½" (16.5 cm) from the left edge, score a line with bone folder, fold on the score mark, and burnish with the bone folder. Reopen the paper. The paper on the left of the fold is the cover, and the paper to the right is the book block **(A)**.

2. Bring the right edge to fold line created in step 1, bending the book block in half. Burnish the new fold with the bone folder **(B)**.

3. Bring the right edge to the fold line again, bending the book block in half. Burnish the new fold **(C)**.

4. Unfold the book block. Bring the second fold from the left to the first fold, dividing that section in half. Burnish the fold. Repeat this step, bringing the third and fourth folds and the end of the piece of paper to the first fold **(D)**.

5. Open the paper and, starting with second fold, bring each fold up to the first fold. Fold each section in half and burnish each new fold. Leave the book block folded **(E)**.

You can create two types of covers. The first is a regular book cover; the second is a cover that wraps over the fore edge of book block and onto the front.

To make a cover that opens like a book:

1. Fold the cover sheet behind the book block.

2. Trim off ½" (1.3 cm) from the top end of the page of the book block's right edge.

3. Score the cover for the spine along the left-hand side of the book block. Measure ½" (1.3 cm) to the left of the score mark and score again. Fold in on score marks **(A)**.

4. Bring the cover up over the spine and along the top of the book block. Fold in the extra inch (2.5 cm) at the end of the cover and reopen the cover (See the second step in the diagram) **(B)**.

5. Place a piece of red liner tape at the base of the flap on the front cover. Tape the flap down **(B)**.

6. Place the trimmed top page of the book block under the taped-down flap and close the book.

To make a cover that wraps over the book front, follow steps 1 through 4 from the cover instructions at left.

5. Score another line on the flap ½" (1.3 cm) to left of line created in step 4.

Fold the book up, and you're ready to fill it with drawings.

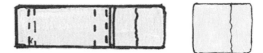

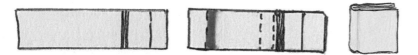

A B

▲ **Blank books**
Changing the size of the paper will change the book's shape.

Tangle Journey

◀ Drew Emborsky chose to create a wrap on his book "Hidden Garden." His love of gardens has always fueled his passion for tangling and inspired this little book. The outside is leafy, airy, and whimsical; the hidden garden inside is full of unexpected sculptural textures woven throughout the organic patterns.

◀ Scrap page with pen drawings
Dedicated to old-school drawing. Many people's first experience with drawing in repetitive patterns happened on the margins and covers of school notebooks.

▼ Examples of inside pages

I used scrap paper to test inks and mediums before recommending them in this book (right). The whole book was drawn with the original four ink colors (blue, black, red, and green) and the four new ink colors (bright green, pink, purple, and light blue) of Bic ballpoint pens. I used the four-in-one pens (Bic Four-Color Fashion pen) for a finer line, and regular ballpoint pen (Bic Cristal) for broader lines to carry the theme throughout the book.

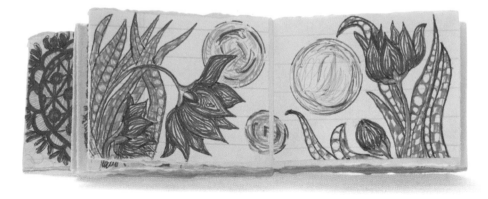

◄ *This piece by Sarah Hodsdon, titled* Maker Faire Tour 2014 . . . Oh the Places You Will Go, *highlighted fifteen states that she drove through. On the front side of each page is the state's shape from the maps they followed on the trip and the roads that connected them; on the back of the page are tangles and emulations of objects seen from the car window, captured with a blue Bic pen, and fashioned into interesting tangles on the fly.*

◄ *In Sarah Hodsdon's* Sticking Abstract, *bits of hand-cut tape were creatively placed in the same methodical way one would draw ink lines. The end result is an abstract with tangible layers. This piece used decorative* washi *tape as a background to highlight the color-blocked masking-tape overlays (both tapes are from Scotch).*

▶ **Small book with printed covers**

This book was created with prints using a Scratch-Foam, Soft-Surface Printing Board. This 2¼" x 1¾" (5.7 x 4.4 cm) piece was made from the triangular piece cut out in step 4 when making the Sketchfolio, page 15. It's very user-friendly: just cut the foam to size and draw the graphics using a ballpoint pen. Ink the foam using a hard rubber roller and water-based printing ink, place on top of your blank page, then rub the back of the foam to ensure contact, and lift it off.

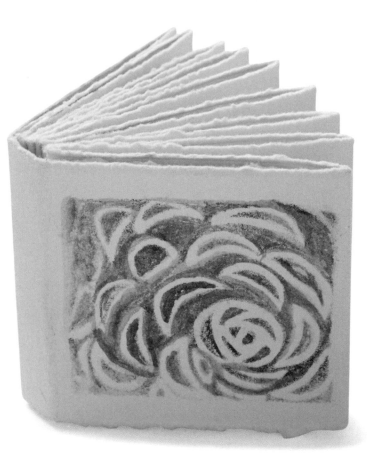

▲ *Plates used to print the cover*

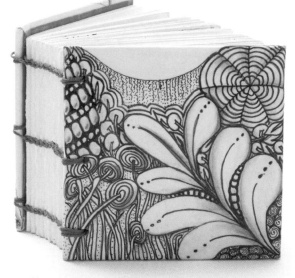

▲ *You can use any of the bindings from this book to create small art books. This 3½" x 3½" x 2½" (9 x 9 x 6.4 cm) piece was made when I started learning to tangle to keep my step-out tangle patterns in.*

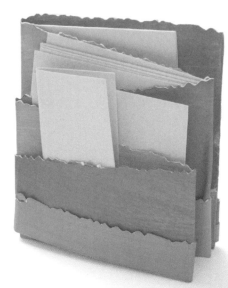

◀ *This is a small art book version of the sketchfolio.*

Plein Air Good for the Journey

Working outside of our usual art space expands our senses and feeds our journey.

The plein air exercises so far have used tiles, sketchbooks, and folded maps to show some nontraditional ways to capture landscapes, cityscapes, organic wonders, or interesting designs.

Packing light when working plein air is key to enjoying the experience. Bring a small collection of supplies. Keep paints, pencils, or pens to sets of eight or fewer, and only carry what you plan to use.

You do not have to travel far; in fact some of the best lessons come from places nearby that can be drawn at different times of the day, and in changing weather and seasons.

▲ **Evergreen**
This spring drawing was done with three Chameleon pens and a drawing pen.

▲ **Inktense paint book**

These folded paint books are made from scrap watercolor paper. The large one is a portable watercolor palette; the smaller is an ink palette created with Inktense pencils. Fold the paper in half. Cover one half of the pallet with packing tape to create a blending area. Create a grid on the other half and color in the grid with water-soluble pencils or sticks of your choice. It's easy to carry—just throw in a water brush and you're good to go.

▲ *Gouache painting of buildings*

▲ *The storm is coming.*

▲ *The storm: Day 4*

In my first study of the buildings, I captured their shapes quickly one hazy, cold afternoon while grabbing coffee across the street. It is an example of the first step to tangling a cityscape, landscape, barn, or interesting sculpture.

Several weeks later, I went back to the coffee shop on a day when rain was forecast, to paint the area again. This piece shows a finished tangled cityscape. After the buildings shapes where drawn, I added the grids that represent the floors and windows of the buildings. I decided to use the patterns that the buildings' reflections were making in the puddles for the tangles on the buildings and placed them within the grids there.

This piece (left) was done four days later. It had been raining all four days and was very gray, dark, foggy, and soaked. Again working from the coffee shop, I used the same tangles and color scheme, but the change in light and atmosphere created a very different mood and look.

Try to find those places in your area that inspire you to create a tangled scape. Bring a limited amount of items to work with and keep the piece small so you have time to finish. Revisit that area periodically to repeat the drawing, as any seasonal or atmospheric changes can inspire you on that visit.

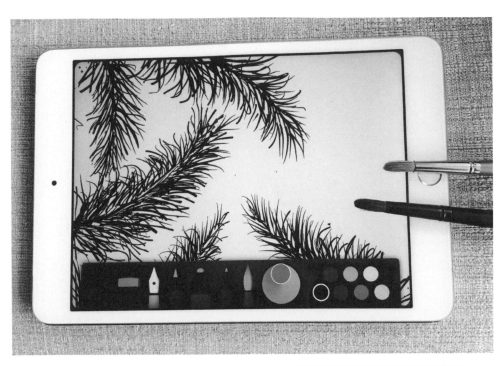

◄ The Sensu Artist Brush and Stylus work with any touch screen. There are several drawing apps that let you draw or paint with the brush and will save your artwork in a virtual sketchpad.

▶ This piece was drawn using the app ArtStudio and the Sensu brush. Easy to use, the program gives you capability to draw or paint, and adjust the width and type of mark you will make. It comes with a huge selection of colors to choose from. I find the brush responds well and is enjoyable to work with.

▶ This picture of feathers was drawn using a Sensu brush in Studio 53, which also is easy to use with many of the same options as the other drawing apps. I like that your art is kept in virtual sketchbooks you can fill, and it becomes a valuable reference you can easily go back to.

When I have an appointment that includes waiting time or travel, I always have my phone or tablet with me. Just as they are resources for so much in our lives, they are now capable of being a portable studio.

Appendix A: Binding

Knots to Tie Off Bindings

Use some extra thread to practice the knots if you are unfamiliar with them.

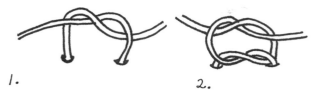

1.

2.

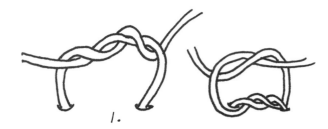

1.

Tying a Square Knot

To create a square knot, place one of the two threads to be tied in your right hand and the other in your left hand. To create the first half of the knot, wrap the cord in your right hand around the cord in your left hand. Pull the ends of the cord to position the knot into place. Wrap the cord in your left hand around the right cord and tighten in place.

Tying a Surgeon's Knot

To create a surgeon's knot, place one of the two cords in your right hand the other in your left hand. To create the first half of the knot, wrap the cord in your right hand around the cord in your left hand twice. Pull the ends of the cord to position the knot into place. Wrap the cord in your left hand around the right cord and tighten in place.

Pamphlet Stitch Binding

Materials

pages and covers folded and binding holes punched as described in chapter 3 (page 69)

14" (35.6 cm) length of two- or four-ply waxed binding thread for a book about 5" x 5" (12.7 x 12.7 cm)

binding needle or size 18 crewel needle

▲ *The cover and pages are in position to bind.*

Instructions

1. Place the pages top side up inside the cover. Open the book to its center and align the page's binding holes with cover's binding holes.

2. Thread the needle with 14" (35.6 cm) of waxed binding thread.

3. Starting from the outside, insert the needle into the center hole through both the cover and pages, leaving a 4" (10.2 cm) tail **(A)**.

4. Place needle into top hole and pull through to the outside of the book, carefully pulling the thread taut **(B)**.

5. Bring the needle down the spine to the center hole, insert it, and pull it through to the inside **(C)**.

6. Bring needle down the spine to the bottom hole, feed it through, and pull it to the outside of cover **(D)**.

7. Bring the needle up to the middle hole and pass it through to the inside.

8. Remove the needle and tie the thread tails together in a square knot (see page 134). Place a drop of glue on the knot. When dry, trim the thread to ⅛" (3 mm).

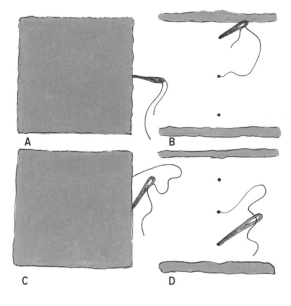

▲ *Sewing pamphlet stitch*

Coptic Stitch

Materials

pages folded and punched as instructed in chapter 3 (page 69)

covers punched as instructed in chapter 3 (page 69)

4' (1.2 m) of two- or four-ply waxed binding thread

curved or binding needle

glue (I used US ArtQuest's PPA)

Instructions

1. Place the covers in front of you with the back side up. Align the top of the front cover with the top of the first signature, signature against inside of cover. With your thumb in the middle of the signature, place the needle from inside through the top binding hole of signature, leaving a 2" (5 cm) tail inside the signature.

2. Place the needle between the cover and the signature and into the first binding hole on the cover. Pull the thread through until taut. Place the needle again between the signature and cover, bringing the needle back through first binding hole in cover **(A)**.

3. Finish the stitch by bringing the needle back into the top hole of the signature **(B)**.

4. Travel inside the signature to the second hole of the signature, and place the needle through to the outside. Bring the needle between the signature and cover, and up into the second hole in the cover. Place the needle between the signature and cover and again up into the second hole of the cover. Pull the thread taut. Go back into second hole of signature. Travel inside the signature to third binding hole **(C)**.

5. Repeat step 4 to sew the third and fourth binding holes in the signature to the cover. Stop after the second time you pass the needle and thread through the fourth binding hole on the cover. Close the first signature.

6. After the second pass through the cover, pick up the next signature. Align the top of the second signature (shown in gray) with top of the first signature. Bring the needle under the thread running between the cover and the first signature into fourth binding hole of second signature, pulling the thread taut **(D)**.

7. Place the needle through the next binding hole. Make a kettle stitch (see diagram) by sliding the needle under thread that runs between cover and first signature, pull the thread taut, and place the needle back through the third binding hole **(E)**.

8. Repeat step 7 for the remaining holes of the signature. After you make a kettle stitch on first binding hole, close the second signature **(F)**.

9. Align the top of the third signature with the top of the previously sewn signatures.

10. Place the needle into the aligning binding hole of new signature. Traveling inside, place the needle through next binding hole to the outside. Make a kettle stitch by sliding the needle under the thread that runs between the first two signatures. Follow the diagram to kettle stitch the next three binding holes, stopping after the signature's last kettle stitch. Close the signature **(G)**.

11. Line up the top of the fourth signature with the sewn signatures' tops.

12. Bring the needle into the fourth signature's fourth binding hole, pulling the thread taut. Repeat step 10 to complete the fourth signature **(H)**.

13. Line up the fifth signature's top with the top of the previously sewn signatures.

14. Bring the needle into the first binding hole in the new signature, pulling the thread taut. Repeat step 10 to finish connecting fifth signature **(I)**.

15. Line up the sixth signature's top with the top of the previously sewn signatures.

16. Bring the needle through fourth binding hole of sixth signature, pulling thread taut. Place the needle into the fourth binding hole of the new signature. Traveling inside, pass the needle through the next binding hole to the outside. Make a kettle stitch by sliding the needle under the thread that runs between the first two signatures. Follow the diagram to kettle stitch the next three binding holes, stopping after the signature's last kettle stitch. Close the signature **(J)**.

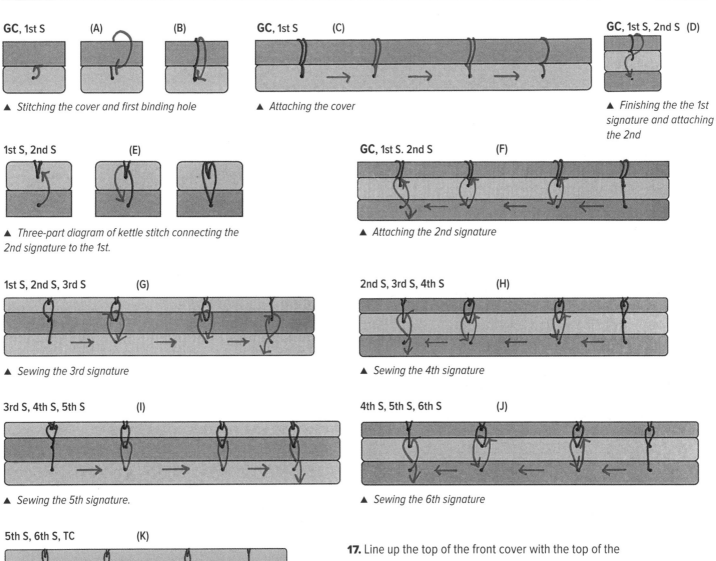

GC, 1st S **(A)** **(B)**

▲ *Stitching the cover and first binding hole*

GC, 1st S **(C)**

▲ *Attaching the cover*

GC, 1st S, 2nd S **(D)**

▲ *Finishing the the 1st signature and attaching the 2nd*

1st S, 2nd S **(E)**

▲ *Three-part diagram of kettle stitch connecting the 2nd signature to the 1st.*

GC, 1st S. 2nd S **(F)**

▲ *Attaching the 2nd signature*

1st S, 2nd S, 3rd S **(G)**

▲ *Sewing the 3rd signature*

2nd S, 3rd S, 4th S **(H)**

▲ *Sewing the 4th signature*

3rd S, 4th S, 5th S **(I)**

▲ *Sewing the 5th signature.*

4th S, 5th S, 6th S **(J)**

▲ *Sewing the 6th signature*

5th S, 6th S, TC **(K)**

▲ *Attaching the rest of the back cover*

A video of Beckah binding her mid-toned book can be found on her website, www.Beckahnings.com, and also on www.quartoknows.com/page/tangle-journey.

17. Line up the top of the front cover with the top of the signatures. Follow steps 1–3 to stitch the first binding hole of the back cover in place.

18. Repeat steps 4 and 5 to attach the back cover (shown in tan), this time traveling again through the sixth signature to stitch the remaining three cover holes **(K)**.

19. Go back into the fourth binding hole and tie off the binding thread with a knot. Place glue on knot and trim the binding thread after glue dries. Repeat for the tail at the front of the book.

Appendix B: Tangle Library

Each tangle is diagrammed with the new step drawn in red. The last example of each tangle gives an example on how to shade the tangle. The Tangles below are original tangles from Zentangle, Inc.

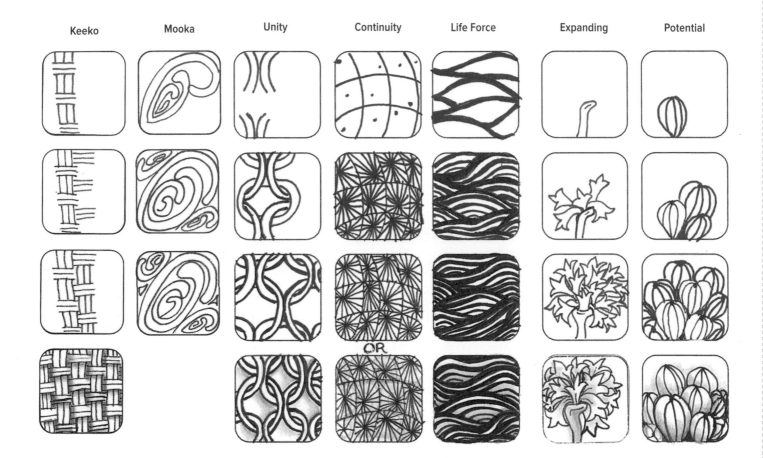

Keeko Mooka Unity Continuity Life Force Expanding Potential

Many of the tangles shown are found throughout art history and can symbolize certain traits or emotions. The stepouts to the tangles Tagh, Shattuck, Verdigõgh, Tipple, and Nekton can be found in *One Zentangle a Day*.

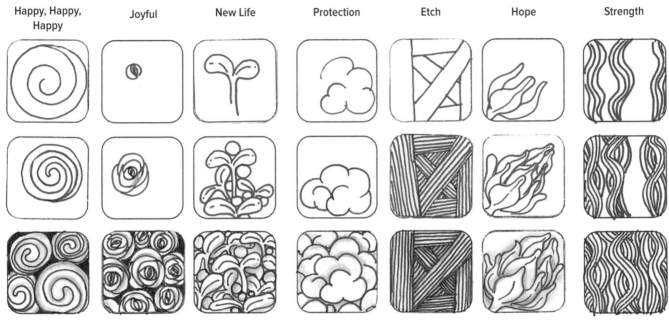

| Happy, Happy, Happy | Joyful | New Life | Protection | Etch | Hope | Strength |

| Love | Immortality | Energy | Renew | D by Bette Abdu | Scholar | Pop |

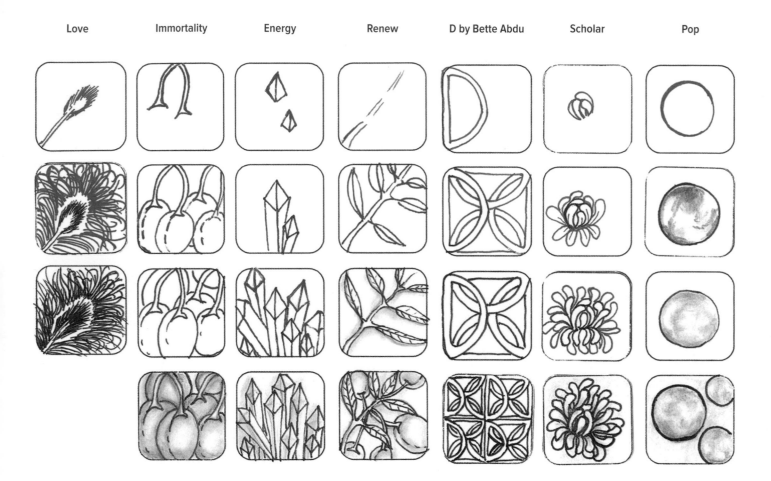

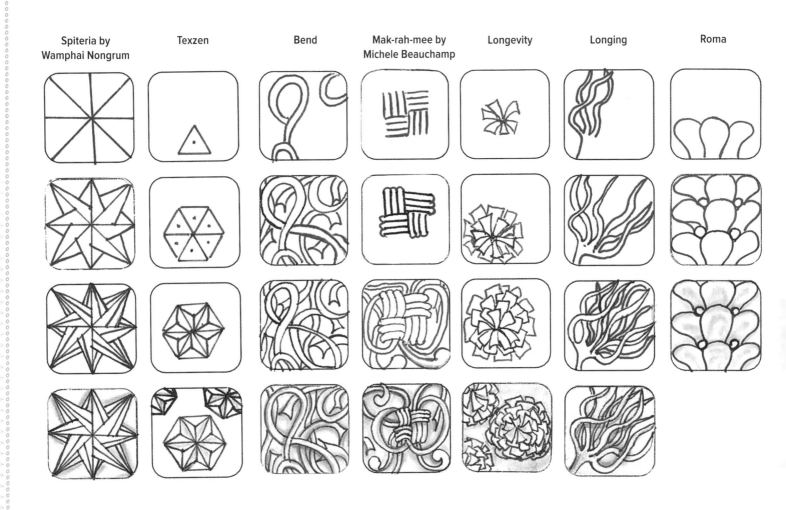

Spiteria by Wamphai Nongrum Texzen Bend Mak-rah-mee by Michele Beauchamp Longevity Longing Roma

Contributors

Sharla Hicks is a Certified Zentangle Teacher, a.k.a. CZT. Sharla crosses the boundaries of expressive artist, writer, painter, quilter, textile artist, collage artist, printmaker, and more. Her current focus is offering the gift of Zentangle to others through lectures, workshops, and retreats. You can reach her at sharlahicks.com or email her at info@SharlaHicks.com.

Judy Lehman, CZT, designs and teaches private, local, and national art workshops. She has published many articles, instructions, and illustrations in a variety of art books. Judy continues to teach art at all experience levels. Contact her at lehmanjudy@sbcglobal.net.

Liz Allen is an instructor, rubber stamp designer, and art experimenter, who has a love for anything paper and embellished. She demonstrates at national art conventions, enjoys teaching new technique workshops, and specializes in creating customized memory books, cards, and invitations for special occasions. You can view more of her work and purchase it at paperwingsproductions.com.

Michele Muska works in the craft, needle arts, and quilting industry. She is an author and a fiber artist who also loves to work in mixed media and paper arts. Her work is featured in many national magazines, books, and on public TV. You can learn more about, and contact Michele, at lolarae.com.

Angie Vangalis is a lettering artist, author, and teacher. Her creations have been showcased at the Craft & Hobby Association convention, featured in news and trade publications, as well as published in ten different books. Her company, AV Graphics, provides publishing, marketing solutions, and training for small creative businesses. You can contact her at angievangalis.com.

Cris Letourneau is an author, artist, and CZT. Since 2010, she has been teaching Zentangle to people of all ages and walks of life throughout the United States and Canada. Her two Zentangle books have each been number one on Amazon.com She can be reached at her website TangledUpInArt.com.

Drew Emborsky has gone from unknown crafter to world-famous, lifestyle guru in just a few short years. Fans know him from his many published books, PBS television show, blog, line of branded products distributed worldwide, and his hand-dyed yarns. Learn more about Drew at drewemborsky.com.

Sarah Hodsdon is an internationally recognized and award-winning artist, designer, writer, and maker at Sarahndipitous Studios. You can reach her at sarahndipitous.com.

Abigael Hodsdon is an artist on call with Sarahndipitous Studios as well as a frequent instructor and speaker at several Maker Faires. She is an 11-year-old hackschooler and also happens to be Sarah's daughter.

Magdalena Muldoon has been teaching metal embossing for twenty years and has written the *Metal Embossing Workshop*. Her metal and Zentangle-inspired work also appears in several publications. She can be contacted at msofia@me.com or mercartusa.com, or you can follow her blog at mercartsmetalembossing.blogspot.com.

Zac Thomas graduated in 2009 from Sam Houston State University with a Bachelor of Fine Arts in Advertising Graphic Design. He currently resides in Houston, Texas, and freelances for local businesses. Reach him at hellozacthomas.com or hellozacthomas@gmail.com.

Resources

If you have a local art-supply store nearby, start there. Nothing replaces being able to try various drawing pens, colored pencils, or markers to see which preform best for you. Following are a few great sources for every artists' materials.

BECKAH KRAHULA
Innovative art, products, tips, techniques, class schedules, and online classes
Beckahnings.com.com

For a video of the coptic-stitch binding technique, go to www.quartoknows.com/page/tangle-journey or to Beckah's website, Beckahnings.com.

DANIEL SMITH
Art supplies for watercolors and watercolor grounds
danielsmith.com

DESIGN MICA COMPANY
Wide range of both natural and industrial mica in all colors
etsy.com/shop/danielessig

PAPER AND INK ARTS
Selection of supplies, specializing in paper and ink
paperinkarts.com

ART SUPPLY ON MAIN
Events, unusual products, tools, and great gift items
artsupplyonmain.com

QUEEN'S INK
Zentangle supplies such as clay boards, Gelatoes, Soleil, and curing lamps
queensink.com

TEXAS ART SUPPLY
For pastels, colored pencils, markers, crayons, and general art supplies
texasart.com

ZENTANGLE HOME PAGE
To find your closest CZT for classes and supplies
zentangle.com

About the Author

Beckah Krahula is the author of the best-selling, award-winning book, *One Zentangle a Day*, the *Tangle Art Pack: A Meditative Drawing Kit and Sketchpad*, and *500 Tangled Artworks*. She is an artist, designer, developer, maker, and CZT.

Information on her innovative art, products, tips and techniques, class schedules, and online classes can be found at Beckahnings.com. She has taught nationally and internationally since 1996. Follow her passion for creating art, her own tangle journey, and many tips and techniques on her blog.

Acknowledgments

I would like to thank my editor Mary Ann Hall, project manager Betsy Gammons, and the staff at Quarto Publishing Group for all the dedication, help, and hard work they brought to *Tangle Journey*. I would also like to thank Bette Abdu, Wamphai Nongrum, and Michele Beauchamp for contributing their inspiring and creative tangles. Special thanks to the following artists who contributed their art and expertise to the journey: Angie Vangalis, Cris Letourneau, Abi Hodsdon, Liz Allen, Jessica Johnson, Michelle Muska, Sharla Hicks, Judy Lehman, Sarah Hodsdon, Magdelena Muldoon, Drew Emborsky, and Zac Thomas.

Last, but not least, to my friends and family for all the loving encouragement, proofing, critiquing, and endless support— I owe you; thanks for always being there.